IMAGES
of America

PIERCE COUNTY
GEORGIA

D1596639

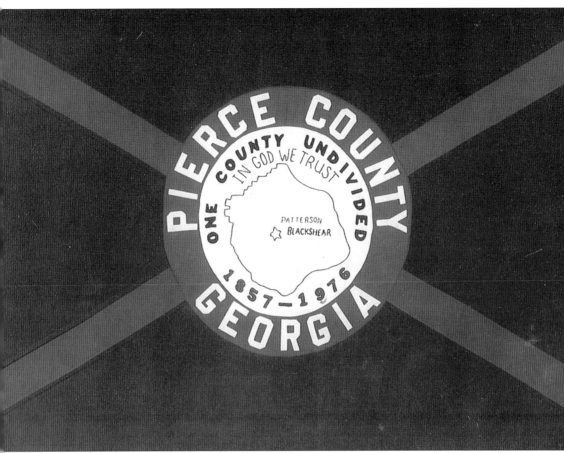

This flag was created during the American Bicentennial Celebration in 1976. A contest was held throughout Pierce County to create a commemorative flag symbolizing the county. Charles Bryant designed the flag and Charlotte Crews sewed it. The original flag is on display inside the Pierce County Courthouse. (Courtesy of Charles Bryant.)

IMAGES
of America

PIERCE COUNTY
GEORGIA

John Walker Guss

Preserve History!

John Guss

ARCADIA

Published by Arcadia Publishing,
an imprint of Tempus Publishing, Inc.
2 Cumberland Street
Charleston, SC 29401

Printed in Great Britain.

For all general information contact Arcadia Publishing at:
Telephone 843-853-2070
Fax 843-853-0044
E-Mail sales@arcadiapublishing.com

For customer service and orders:
Toll-Free 1-888-313-2665

Visit us on the internet at http://www.arcadiapublishing.com

This book is dedicated to my father and mother, Earl and Margaret Guss, who have instilled in me a deep appreciation for American history and who have inspired and encouraged me throughout my life in all my endeavors.

CONTENTS

ACKNOWLEDGMENTS

On April 29, 1999, a small group of interested citizens gathered inside the courthouse annex with the intent of forming an organization to direct and promote historic preservation in Pierce County, Georgia. The group became known as the Pierce County Historical and Genealogical Society. This organization prompted a rebirth of interest in the history of the community. For over 140 years, Pierce County had never encased its history in an archival library or museum, much less compiled an actual pictorial history of the county.

Just after the society had been established, Katie White of Arcadia Publishing arrived with a proposal to assist our small agricultural community in telling its wonderful history through pictures. In the beginning, it was doubtful there would be enough photographs to complete the history of Pierce County. However, through a tremendous amount of investigative research, hundreds of photographs began to surface through the generosity and support of members of the society as well as citizens throughout the region who had ties to Pierce County.

This book is the culmination of what has thus far been discovered through old records, photographs, and stories from citizens both present and former. Although it is quite thorough in its presentation, it in no way comes close to telling the entire story of Pierce County and does not attempt such an insurmountable challenge. It is rather a brief glimpse to remind each of us of the legacy of our forefathers, who tilled the land, built the railroad, established homes and churches, and answered the call to defend their nation. It is through these photographs that we remember our heritage. We hope this photographic history will reveal to the reader a legacy of generations long past, the very foundation on which Pierce County was built.

There are so many people who assisted in the completion of this historical document to thank. Many of their names appear throughout this book. However, there are two key individuals who spent countless hours recording detailed manuscripts and composing beautiful photography during their lifetimes; without them, this book as well as the history of Pierce County would be lost forever.

Mr. Dean Broome, the editor of the *Blackshear Times* from the 1940s through the 1970s, gathered many interesting stories and striking photographs from residents all over the county. In turn, he compiled all of these archives into the most comprehensive history of Pierce County to date.

Another gentleman, Jim Hendry, whose family was one of the first to settle the colony of Georgia, was a well-known photographer in South Georgia during the mid-1900s. His expertise in capturing people, places, and events is evident throughout this volume. It was through the generosity and wealth of knowledge of his wife, Ruth, that we are extremely fortunate to have these precious treasures.

Aside from the contributions of these distinguished gentlemen, the support of the members of the Pierce County Historical and Genealogical Society and the citizens of Pierce County made this project possible. It is with deep appreciation for this community effort that all proceeds from this book will be put toward the continuing preservation of historic Pierce County, Georgia.

INTRODUCTION

Pierce County, Georgia has a long and prosperous history that dates to a much earlier time than the county's formal establishment and has its foundation in the settlements of Native Americans of the Creek Nation. Artifacts of arrowheads and pottery continue to be discovered throughout the county where countless numbers of Creek Indians once lived.

When the War of 1812 and the Creek Wars began, Gen. David Blackshear was ordered to sweep through the region and remove these first inhabitants. He was also authorized to construct a military road that would become the tangible beginning of Pierce County's fascinating history.

Incorporated in 1857, the county was given its name in honor of the 14th President of the United States, Franklin Pierce (1853–1857). Soon thereafter, Blackshear was established and named for Gen. David Blackshear. It was not long after the county's establishment that its citizens had to make an important and difficult decision—whether they would remain loyal to the Union or join their fellow Georgians in the formation of a new government. When the Civil War erupted, many of Pierce County's sons were sent away to the distant battlefields in Virginia, Pennsylvania, Maryland, and Tennessee. While the men were away fighting, the rest of the citizens held the community together. They too felt the harsh realities of war firsthand in November 1864, when some 5,000 Union prisoners were brought to Blackshear for imprisonment. At the time, there were only 333 households in the entire county. Although these dying Union soldiers were fighting against the cause Pierce Countians were defending, the people offered what little food they had to the deprived prisoners.

As the war came to a close, the men returned home to continue what they had begun— building a community. However, Reconstruction did not make it easy for citizens to rebuild their lives immediately. Union soldiers of the 12th Maine were sent to reinforce new government policy, and many of the residents of Pierce County, as in other communities, had difficulties adjusting to the changes. Nevertheless, in a short time the soldiers left the citizens to govern themselves. Since there had been fewer than 20 slaves in Pierce County prior to the Civil War, their emancipation did not cause any drastic changes in the way people carried out their business. Many citizens were farmers. Timber and cotton had been the agricultural mainstays, but when cotton became infected by the boll weevil, local farmers were in urgent need of a new crop.

In the 1870s, tobacco, which would become the major cash crop through the next century, was introduced in Pierce County. Tobacco warehouses, such as the Brantley Brick Warehouse and Big Z and Planters, were constructed in the town limits of Blackshear, making it the site for farmers—both local and in the surrounding counties—to bring their tobacco to market. As farming prospered, other businesses and other communities, such as Patterson, Offerman, Bristol, Mershon, Otter Creek, Hacklebarney, Schlatterville, Aspinwall (Wall's Siding), Walkerville, and Zirkle, sprang up. Timber and turpentine continued to become major contributors to the local economy, and some citizens traveled to Waycross to work at the bustling railroad yards.

As quickly as an economy was beginning to take shape the Great Depression began and Pierce County found itself struck as hard as anywhere else in the country. Sad stories are told to this day by those who lived through it. Unexpectedly, in 1941, the men of Pierce County once again went off to war to defend their country. They had fought in the Spanish-American War and World War I, but this was a war in which they would defend the entire world. These citizens of strong Christian faith banned together and endured this most challenging test in American history. When the men returned home, Pierce County moved forward, without looking back.

The people of Pierce County are a diversified group, but they share a common interest and a sincere pride in their heritage and the future of their community. These citizens have held fast to Christian values, the foundation of this county, and through that, they have built a thriving and long-lasting community. This book is a tribute to the accomplishments and the legacy of the men and women who built Pierce County, Georgia.

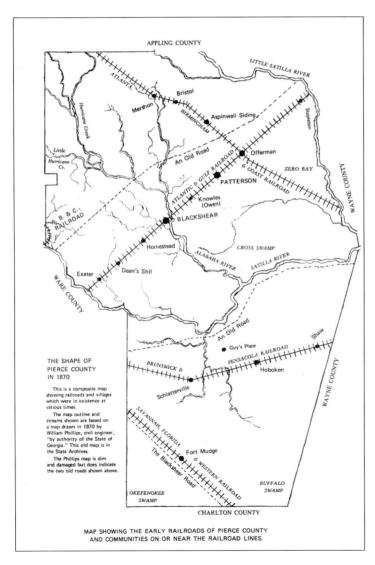

This is a map of Pierce County. (Courtesy of Dean Broome, *The History of Pierce County*.)

One

A County is Born

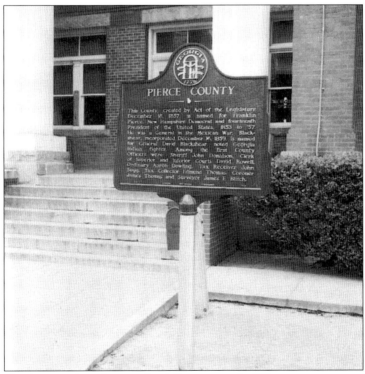

Inscribed on this historical marker are the following words: "This county, created by an act of the legislature on December 18, 1857, is named for Franklin Pierce, New Hampshire Democrat, and fourteenth President of the United States (1853–1857). He was a general in the Mexican War. Blackshear, incorporated December 16, 1859, is named for Gen. David Blackshear, noted Georgia Indian fighter. Among the first county officers were Sheriff John Donaldson, Clerk of Superior and Inferior Courts David Rowell, Ordinary Aaron Dowling, Tax Receiver John Sugg, Tax Collector Edmund Thomas, Coroner James Thomas, and Surveyor James E. Blitch."

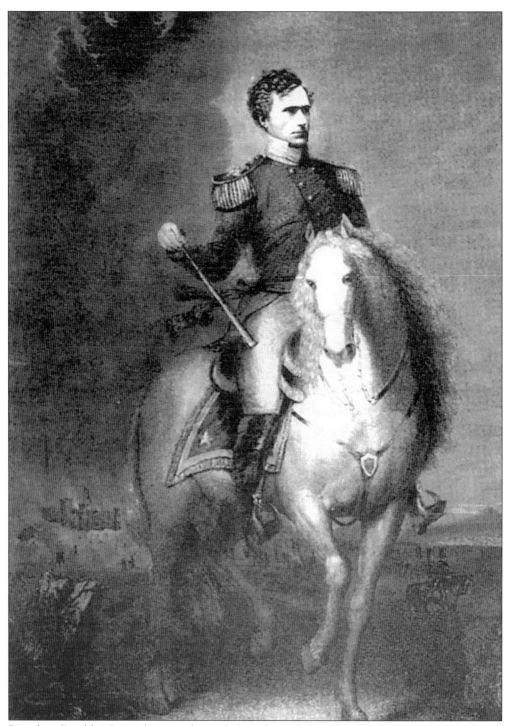

President Franklin Pierce became the 14th President of the United States in 1853. He served as a brigadier general in the Mexican War and later as a U.S. representative and senator. Toward the end of Pierce's presidency, a new county in South Georgia was formed and named in his honor.

David Blackshear grew up in North Carolina during the time of the American Revolution. He served the American cause when only 12 years old, fighting alongside his brothers at the Battle of Moore's Creek. He served in other campaigns as well. After the war, Blackshear moved to Georgia where he became a surveyor. When the War of 1812 broke out, he came to the aid of his country once again, quickly rising to the rank of brigadier general. One of his responsibilities was to build roads through Georgia to help improve the movement of troops and supplies from one end of the state to the other. One of those roads was built through the vicinity of what is now Pierce County. (Courtesy of the Pierce County Historical & Genealogical Society, Inc.)

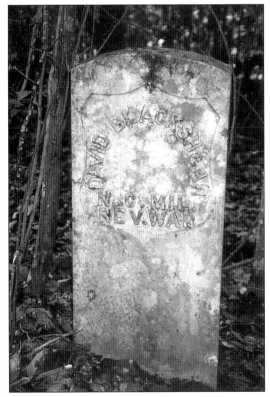

David Blackshear received a land grant for his services in helping defend a young America. Blackshear moved to what is now Laurens County and established a plantation he named Springfield. Blackshear, his brother, and several family members are buried in a cemetery where his home once stood. To locate the Blackshear family cemetery, take East Central Drive from the Laurens County Courthouse in Dublin and travel 1.6 miles. Turn left onto Buckeye Road and travel 5.8 miles. Then turn left onto the Blackshear Ferry Road East, County Road 9. Travel approximately one-eighth of a mile. Approximately three-fourths of a mile to your right is the resting place of this long-forgotten hero. (Courtesy of John Guss.)

11

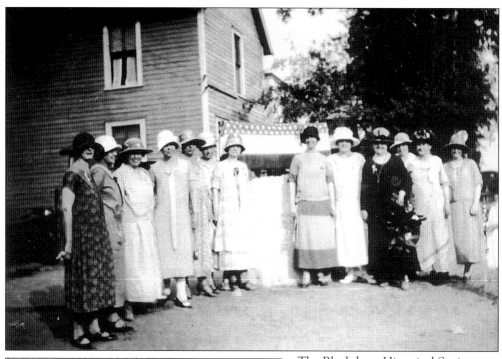

GEN. DAVID BLACKSHEAR
ORDERED THIS MILITARY ROAD
CUT TO DARIEN AND ON TO
ST. MARYS JULY 1ST. 1814

THE MEMBERS
OF THE BLACKSHEAR HISTORICAL SOCIETY
ERECTED THIS TABLET MAY 8, 1925

MRS. ALONZO J. STRICKLAND, PRESIDENT
MRS. ROBERT G. MITCHELL, JR. VICE PRES.
MRS. ELLEN McINTOSH RATLIFF, SECRETARY
MRS. ELLIE L. DAVIS, TREASURER

MRS. W. S. BRUCE MRS. A.H. MACMILLAN
MRS. A.P. DAVIS MRS L.H. ODEN
MRS. E.L. DARLING MRS. T.E. ODEN
MRS. J.E. DAVIS MRS. E.L. PORTER
MRS. O.S. DEAN MRS. I.S. SPRAGUE
MRS. G.T. HENDRY MRS. W.P. STRICKLAND
MRS. WARREN LOTT MRS. J.A. STRICKLAND
 MRS. J.B. TRUETT

The Blackshear Historical Society was established in 1922 with Mrs. A.J. Strickland as its first president and was in existence for 16 years. On May 8, 1925, the organization erected a monument, which stands on the corner of Highway Avenue and Main Street, to commemorate the road built by General Blackshear and his troops. Pictured here, from left to right, are Mrs. J.E. Davis, Mrs. Thomas Oden, Mrs. Maud Dean, Mrs. Bruce Truett, Mrs. E.L. Porter, Mrs. H.V. McMillan, Mrs. A.J. Strickland, Mrs. A.P. Davis, Mrs. Lewis H. Oden Sr., Mrs. R.L. Mitchell, Mrs. Ernestine Purdom Lott, Mrs. Belle Sprague, and Mrs. George Tracy Hendry. (Courtesy of the Pierce County Historical & Genealogical Society, Inc.)

Two
THE GREATEST TEST

When the American Civil War broke out in 1861, Pierce County was a relatively young county. Despite this, the founders of the community stepped forth and committed themselves to serving the newly formed Confederacy. Men volunteered for the companies formed in the surrounding communities, including the Satilla Rangers, Co. A, 50th Georgia Infantry; the Atlantic & Gulf Guards, Co. 26th Georgia Infantry; the 4th Georgia Cavalry; and the 7th Georgia Cavalry. While the men were away fighting the war, citizens got a firsthand view of the horrors they had only read about when more than 5,000 Union prisoners of war arrived by rail from Savannah. They had begun their original journey from the infamous Andersonville Prison.

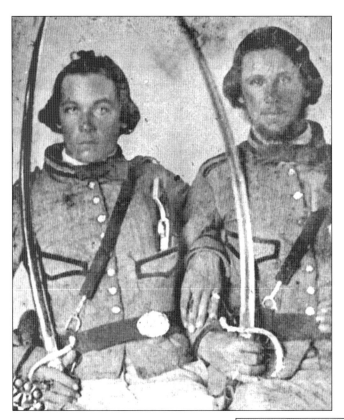

A young Lt. John W. Stephens, left, and Allen Brown were some of the first to join the ranks of the Confederacy in 1861. They would become part of Company A, of Clinch's Cavalry, which later became Company G of the 4th Georgia Cavalry. Allen Brown was promoted to first corporal and served until 1863 when he was injured by a horse and sent home. (Courtesy of Bill Brown.)

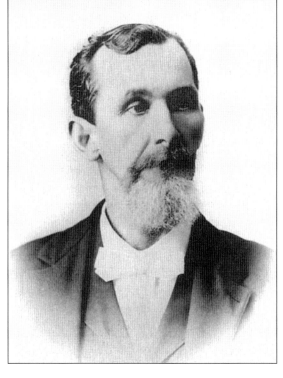

Born in Bulloch County on December 17, 1837, Dr. Allen Brown, seen here later in life, came to Pierce County with his family where his father, William, took up farming. In addition to farming, Allen began practicing dentistry in 1866. He was also the proprietor of the Brown Hotel. Allen Brown was the first of three generations of the Brown family to practice dentistry in Blackshear. He died on August 6, 1906 and is buried in the Blackshear Cemetery. (Courtesy of Bill Brown.)

Jonathan Gilman Clough, the grandfather of Rubye Clough Carter, was another Pierce Countian who rallied to join the Confederate cause. (Courtesy of Rubye Carter.)

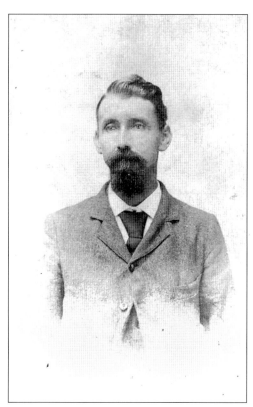

Mrs. Isabella Clough was one of many women who continued to raise a family and care for the home while her husband, Jonathan Gilman Clough, was serving in the Confederate army. He would return home after the war, but she would outlive him and raise four daughters and five sons. (Courtesy of Rubye Carter.)

Dr. Andrew M. Moore enlisted in the 26th Georgia Co. N as a private on September 29, 1861; however, he would muster out on March 31, 1862. After the war, Moore became a respected doctor in the community. He was also the first Sunday school superintendent of Blackshear Presbyterian Church, a position he held from 1874 to 1891.

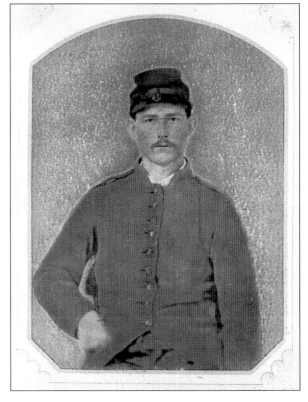

This is one of the few known photographs of a soldier in uniform from Pierce County. Franklin Knox joined the 26th Georgia Infantry in the summer of 1861. Like thousands of soldiers, he died of disease and not from wounds suffered in battle. Typhoid fever took Knox's life on June 30, 1862 while he was in Lynchburg, Virginia. (Courtesy of Ruth Hendry.)

George Nathan Hendry went to Savannah to enlist in the Chatham Artillery at Camp Claghorn on February 28, 1862. He served through the remainder of the war until April 26, 1865 when he was discharged from service. He rests in the Blackshear Cemetery. (Courtesy of Ruth Hendry.)

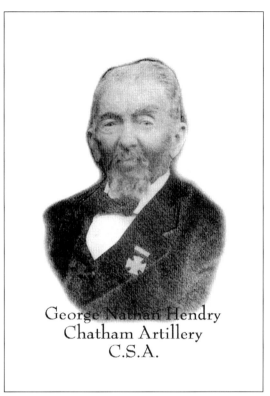

George Nathan Hendry
Chatham Artillery
C.S.A.

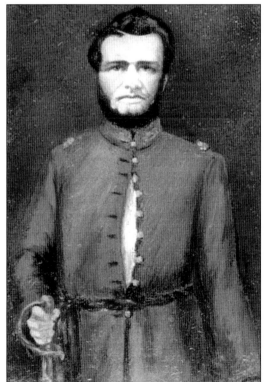

Dr. Henry J. Smith (August 1, 1827–July 10, 1893) rose to the rank of major in the Confederate army. After the war, he established a successful medical practice in Blackshear. He is buried beside his wife, Sophia Hall (October 8, 1832–October 4, 1908), in the Blackshear Cemetery. (Courtesy of the Pierce County Historical & Genealogical Society, Inc.)

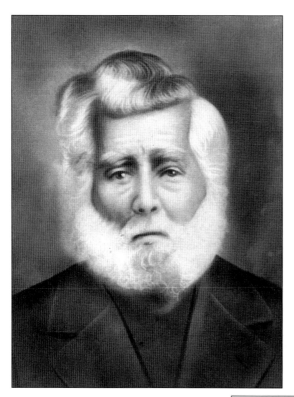

James Rowell (June 4, 1807–April 22, 1915) served in the Georgia Volunteers from 1839 to 1841 during the Indian Wars. After the war, he farmed until the call to arms was sounded again. He then joined the 7th Georgia Cavalry, Company D, CSA. He returned home after the war and lived a very full life. (Courtesy of Don and Helen Rowell.)

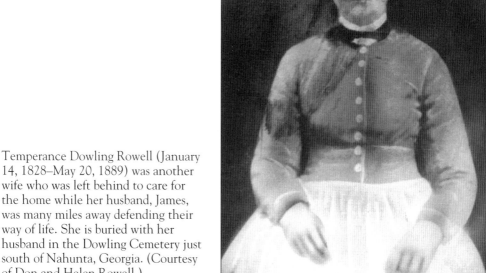

Temperance Dowling Rowell (January 14, 1828–May 20, 1889) was another wife who was left behind to care for the home while her husband, James, was many miles away defending their way of life. She is buried with her husband in the Dowling Cemetery just south of Nahunta, Georgia. (Courtesy of Don and Helen Rowell.)

18

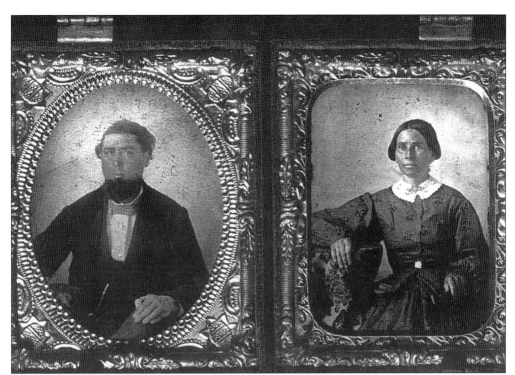

John W. Stephens and his wife, Jane Albritton Jones, posed for this photograph prior to the Civil War. Born in 1830, Stephens was a prominent merchant and was elected, along with E.D. Hendry, to represent Pierce County at the Secession Convention in Milledgeville. The couple had two daughters, Sarah and Charlotte. (Courtesy of Bill Brown.)

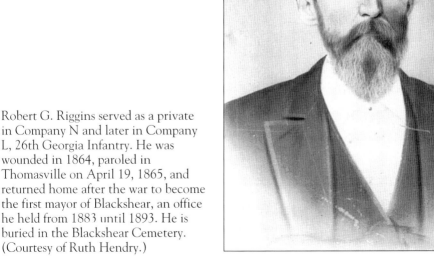

Robert G. Riggins served as a private in Company N and later in Company L, 26th Georgia Infantry. He was wounded in 1864, paroled in Thomasville on April 19, 1865, and returned home after the war to become the first mayor of Blackshear, an office he held from 1883 until 1893. He is buried in the Blackshear Cemetery. (Courtesy of Ruth Hendry.)

George Washington Phillips (February 15, 1834–1906), the great grandfather of Huel Walker, served three years in Company H of the 4th Georgia Cavalry. He is buried in the Shiloh Primitive Baptist Cemetery. (Courtesy of Huel Walker.)

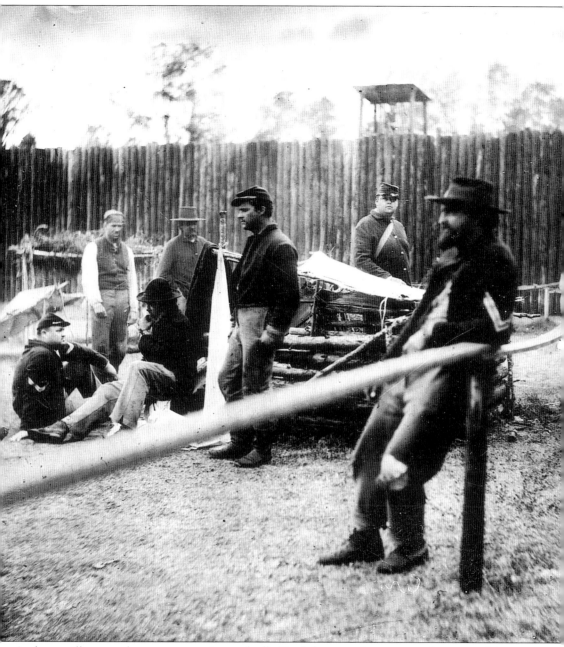

Andersonville was the most notorious of all Confederate prison camps because of its overcrowding and lack of food supplies for the Union prisoners. Over 13,000 soldiers died of malnutrition and abuse. Here, members of the 48th New York reenactment unit portray the life of a prisoner of war during a living history program in March 1999 at the Andersonville National Park. From left to right are Jack Quinn, John Guss, Ronnie Bargainnier, Ken Giddens, Doug Woodall, Steve Birtman, and Bob Lyons. Most likely, there were men of the original 48th New York who were sent to Blackshear. (Courtesy of the 48th New York State Volunteers Company F reenactment unit.)

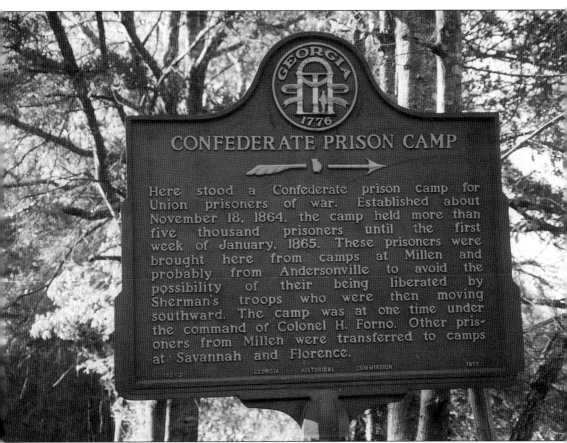

CONFEDERATE PRISON CAMP

Here stood a Confederate prison camp for Union prisoners of war. Established about November 18, 1864, the camp held more than five thousand prisoners until the first week of January, 1865. These prisoners were brought here from camps at Millen and probably from Andersonville to avoid the possibility of their being liberated by Sherman's troops who were then moving southward. The camp was at one time under the command of Colonel H. Forno. Other prisoners from Millen were transferred to camps at Savannah and Florence.

GEORGIA HISTORICAL COMMISSION 1955

When General Sherman and his mighty army of some 60,000 troops moved through the heart of Georgia, Confederate officials were greatly concerned that his army would liberate the prisoners at Andersonville. Those who could travel were sent southeast to a newly established prisoner of war stockade called Camp Millen, south of Augusta. As General Sherman approached the gates of Savannah, Union prisoners were once again shifted to other parts of the state. More than 5,000 of these prisoners were transported by rail on the Atlantic & Gulf Railroad to Blackshear, where they remained for several weeks. After the war, Union soldiers were sent to occupy Blackshear. While there, they recovered the bodies of fellow comrades who had perished while imprisoned at the prison camp. Their remains were reinterred at Beaufort National Cemetery in Beaufort, South Carolina. The prison camp was located on the site where Moore Street and Highway 203 intersect, just on the outskirts of Blackshear. (Courtesy of John Guss.)

John L. Ransom, brigade quartermaster of the 9th Michigan Cavalry, was captured near Rogersville, Tennessee and was sent to Andersonville. He was one of thousands who would eventually be taken to Blackshear. He later wrote a book entitled *John Ransom's Diary* in which he tells of his experiences as a prisoner of war. (Courtesy of *John Ransom's Diary*.)

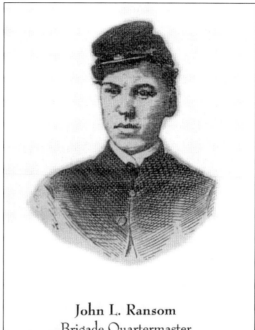

John L. Ransom
Brigade Quartermaster
9th Michigan Cavalry Regiment

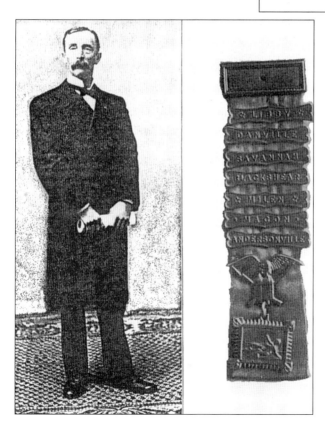

Ralph O. Bates was also a prisoner of war who was sent to Blackshear from Andersonville. He described Blackshear as "a miserable little hamlet in the pine barrens" and recalled the layout of the prison as being completely commanded by earthworks with mounted cannon and some 700 Confederate guards. He was one of the fortunate ones who survived his imprisonment. Bates, along with other heroes, was invited to Washington, D.C., where he was decorated for his bravery by President Grover Cleveland. Note the fourth pin on his medal is listed "Blackshear." (Courtesy of the Pierce County Historical & Genealogical Society, Inc.)

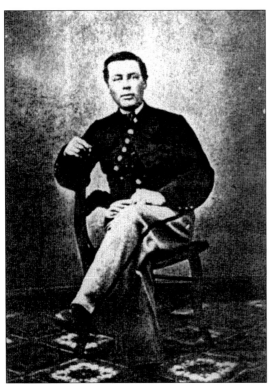

Francis J. Hosmer at the age of 21 enlisted in the 4th Vermont Infantry, Company I. He became a prisoner of war and was first sent to Andersonville; he was later transferred to Blackshear. In his memoirs, Hosmer recalled, "Blackshear has always seemed like an oasis in the memory of those perilous times. Here we were far removed from all the apparent danger and the guards were more humane." He was taken back to Andersonville in December 1864 and was paroled on April 15, 1865. (Courtesy of the Pierce County Historical & Genealogical Society, Inc.)

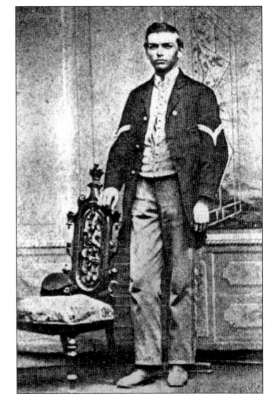

Corp. H.I. Gorham was just 18 years old when he joined the 4th Vermont Infantry. Captured at Ream's Station, south of Petersburg, Virginia, with his comrade Francis Hosmer, he too was sent to Andersonville and later to Blackshear. On Christmas Eve 1864, they would stand once again before the gates of the notorious prison. Gorham would be one of the fortunate soldiers to return home at war's end. (Courtesy of the Pierce County Historical & Genealogical Society, Inc.)

Three

FOUNDATION OF THE COMMUNITY

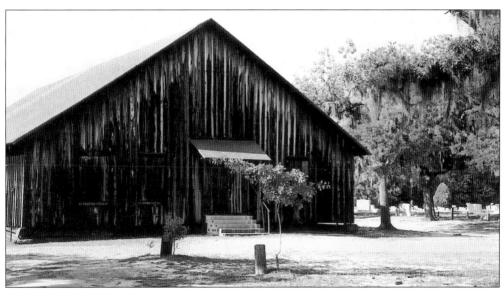

They called it "going to meeting." The people of Pierce County have always maintained a strong Christian belief, and the Sabbath was a holy day. Families gathered in their Sunday best and either walked, rode in wagons or on horseback to meeting. Sometimes the entire day was spent in church. Shiloh Primitive Baptist Church, the oldest known church in Pierce County, was one of many established throughout the county. Located northeast of Blackshear, the church was formed in 1835. Here, the men sat on one side of the sanctuary and the women on the other. A cemetery was later created and contains many of Pierce County's founding families, including at least two known veterans of the American Revolution—Rev. Isham Peacock and James Thomas. Services are still conducted today in essentially the same manner as they were when the church first began. (Courtesy of John Guss.)

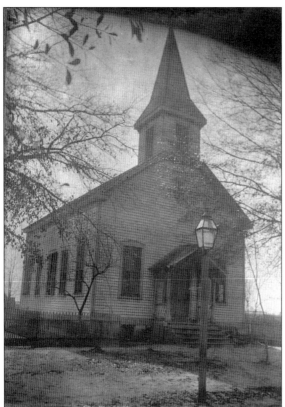

Many Methodists who moved to Pierce County converted to other denominations until a church was established. In her memoirs, Miss Eleanor Stewart wrote about what is believed to be the first Methodist church, established in 1834. She wrote that just after Shiloh Church was built, the Henderson, Newborn, and Sweat families organized a Methodist church where the Henderson family cemetery stands today. The small church ultimately dissolved. The First Methodist Church was established in Blackshear in 1859–1860 and has endured through the years. (Courtesy of Ruth Hendry.)

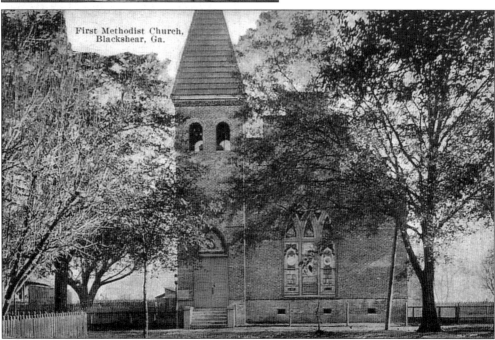

The original First Methodist Church in Blackshear stood until 1905 when a larger structure was built to accommodate the growing congregation. (Courtesy of Lucile Walker Miller.)

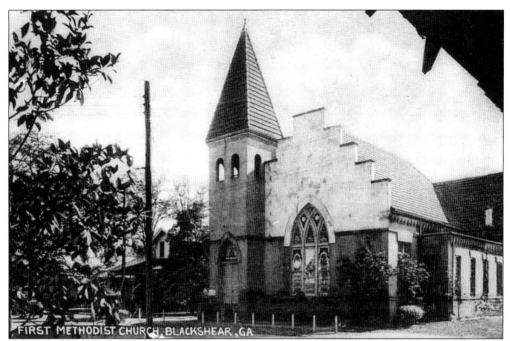

This is another view of the First Methodist Church, which stood throughout the 1900s until a larger church was built to house the ever-growing congregation. (Courtesy of Ruth Hendry.)

Mrs. Maude Grady Dean (1886–1948) stands proudly in her wedding gown. Married in 1905, she was the last to wed in the old wooden church. She taught in Blackshear High School for 27 years before retiring in 1947. She was also a member of the Blackshear Historical Society. (Courtesy of Ruth Hendry.)

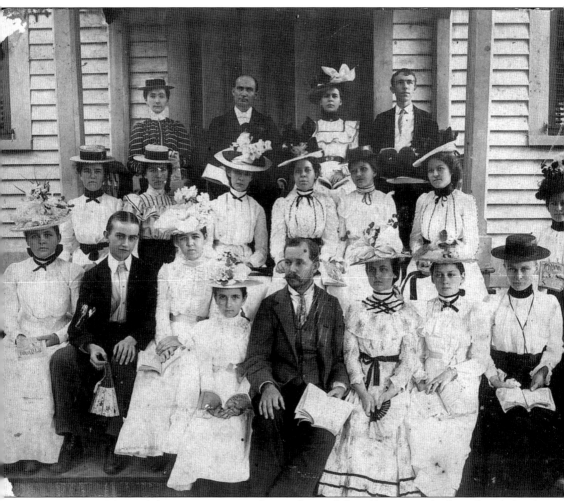

Some members of the congregation gather in front of the old First Methodist Church for this photograph, taken between 1890 and 1920. Pictured, from left to right, are (front row) Ora Riggins Oden, Ed Hughes, Sadie Nichols, Hester Agnes Memory, John B. O'Neal, Janie Brewer Memory, Leila Smith, Lilla Brewton Ward, and John O. Ward; (middle row) Allie Hughes, Viola Strickland Brown, Nettie Memory Bruce, Savannah Shaw, Katie Hughes Nobles, Augusta Shaw Brooker, and Annie Shaw Smith; (back row) Emma Graham, Reverend Beacon, Annie Riggins Porter, and ? Brown. (Courtesy of Ruth Hendry.)

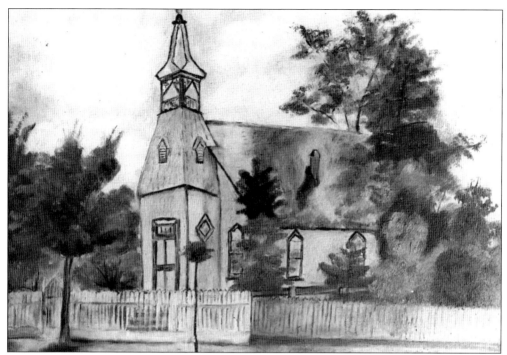

Now the oldest standing church in Blackshear, the Blackshear Presbyterian Church was organized on May 18, 1872 by a committee of the Reverends C.B. King, David Porter, and Montgomery. The church began construction and was completed in 1874. Nettie Brantley Langley, a resident of Blackshear, painted this beautiful watercolor. (Courtesy of Mary Lott Walker.)

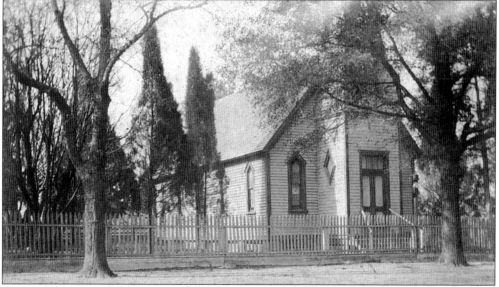

This is a rare photograph of Blackshear Presbyterian Church as it appeared early in its history. Rev. Richard Quarterman Way was its first minister, and Capt. John C. Nichols (CSA) donated the property on which the church was built. Before the construction was completed, services were held at the neighboring First Methodist Church. (Courtesy of Mary Lott Walker.)

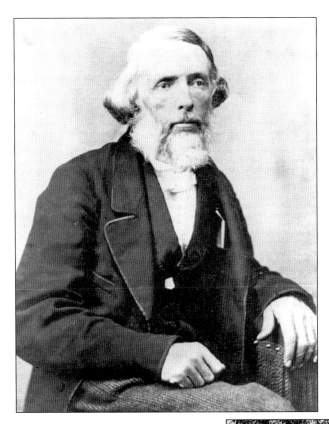

Rev. Richard Quarterman Way served as the first minister of the newly formed Blackshear Presbyterian Church from 1873 to 1875 and 1883 to 1886. He entered the University of Georgia on January 1, 1836 and studied medicine for three years; however, in 1840, he changed his profession and entered the Theological Seminary in Columbia, South Carolina. After graduation, Reverend Way devoted his life to the ministry throughout Southeast Georgia and made a gift of the bell that hangs in the steeple tower of the church. He is buried in Bonaventure Cemetery in Savannah, Georgia.

The Brantley family was one of the many prominent families to worship at Blackshear Presbyterian Church. The congregation was at its peak throughout the early to mid-1900s. Gradually, the congregation's numbers declined as people moved on or passed away; however, the Presbyterians continue to maintain and treasure this historic building in it original state. This late 1800s view of the Blackshear Presbyterian Church reveals the addition of an awning over the front door to protect visitors from the sun and rain. (Courtesy of Mary Lott Walker.)

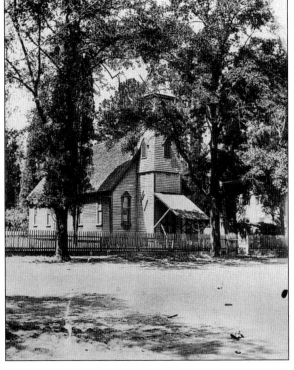

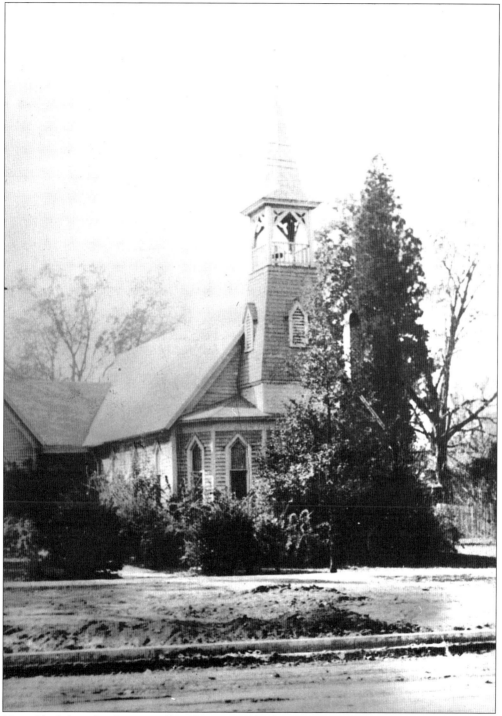

Here, Blackshear Presbyterian Church's exterior looks quite different from years past. Additions were made to accommodate the growing congregation. The fence was removed to make way for sidewalks, and soon curbing was developed along the street as seen in the foreground. (Courtesy of Mary Lott Walker.)

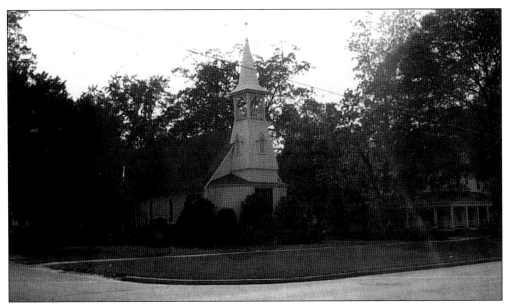

This photograph of Blackshear Presbyterian Church was taken in the 1970s. The sanctuary was damaged in a fire attributed to a candle left burning on the Advent wreath but was later restored. The house on the right was the home of Mr. and Mrs. John Mason Purdom, which was sold to the church and used as Sunday school classrooms and a fellowship hall for several years. The structure was torn down in the 1980s to make room for Willet Hall, the new fellowship hall, and new Sunday school classrooms. (Courtesy of Mary Lott Walker.)

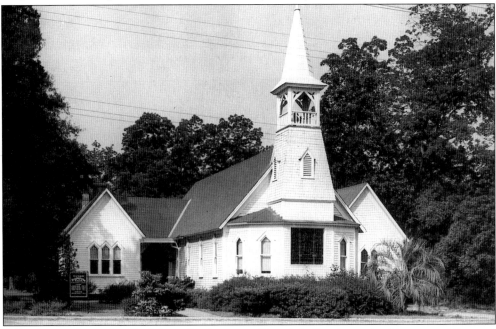

A final view shows the Blackshear Presbyterian Church before it received its new addition of Willett Hall, which was funded through the generosity of Mrs. Julia Brantley Willett, the daughter of A.P. Brantley; members of the congregation; and the Savannah Presbytery. (Courtesy of Mary Lott Walker.)

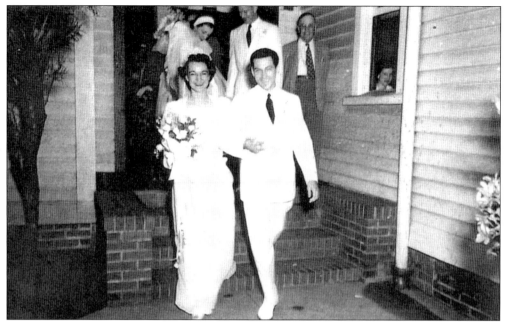

Well-known residents of Blackshear, Alvin and Francis Ratliff were married in the Blackshear Presbyterian Church. Mr. Ratliff was one of the organizers of the People's Bank and was involved in other business ventures. He later became an elder in this church. (Courtesy of John Ratliff.)

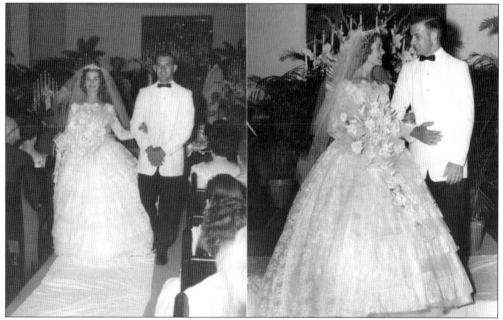

Joseph Leon Carter and Martha Susie Carter were happily married in the Blackshear Presbyterian Church on July 17, 1961. They remained in Pierce County and raised a family. Joe served as an elder and was a former president of the Brantley Company. Susie worked at the Blackshear Bank until she retired. They recently celebrated their 40th wedding anniversary. (Courtesy of Joe and Susie Carter.)

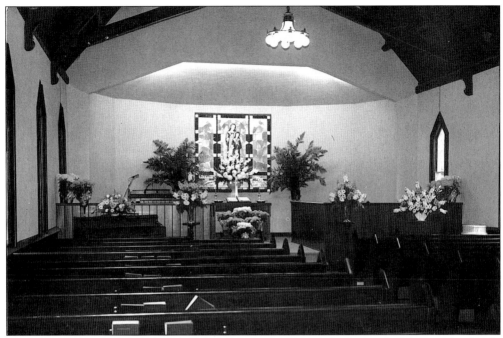

The magnificent interior of the Blackshear Presbyterian Church is a wonderful example of early church architecture of South Georgia. The interior was redesigned in the 1990s; however, the overall integrity of the original woodwork remains. (Courtesy of Mary Lott Walker.)

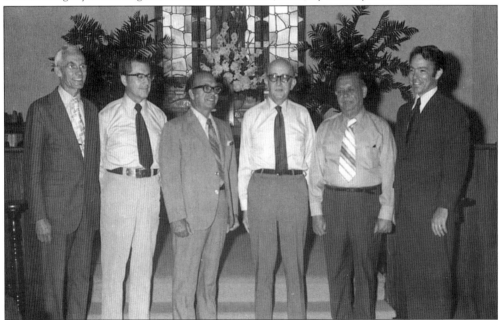

Pictured, from left to right, are Rev. Orlow Rusher, Alvin Ratliff, Rev. Armando Rodriguez, Arthur Lee Howard, Lyman Walker, and Rev. Jack Hill Ward. These men were instrumental in leading the Blackshear Presbyterian Church throughout the 1960s, 1970s, and 1980s. This photograph was taken in May 1972 during the celebration of the 100th anniversary of the founding of the church. (Courtesy of Mary Lott Walker.)

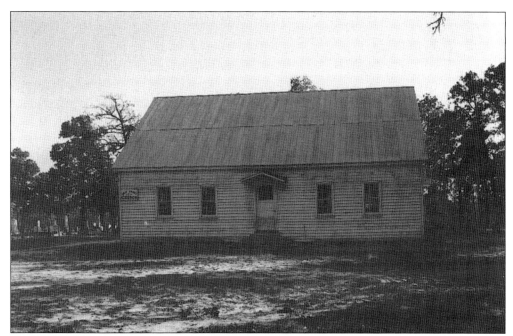

Organized in 1884, the Ben James Primitive Baptist Church, named for Ben James V, is located in the Hacklebarney community southwest of Blackshear. It was another one of the many Primitive Baptist congregations that developed in Pierce County. Many founding fathers of the county are buried in the old cemetery adjacent the church, including Ben James V. (Courtesy of the Pierce County Historical & Genealogical Society, Inc.)

Throughout the pine forests of Pierce County churches, such as the Mill Creek Primitive Baptist Church, sprang up. Located west of Offerman, this church was established around 1890 and, through the years, has maintained a small but dedicated following. (Courtesy of Myrtice Chancey.)

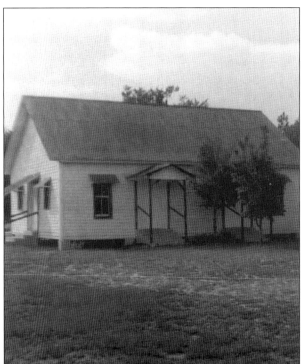

This is a c. 1940 photograph shows a newer Mill Creek Primitive Baptist Church. The cemetery is located in the rear of the church and includes those with such family names as Aspinwall, Boyette, Carter, Cason, Chancey, Crosby, Dixon, Douberly, Hurst, Thomas, Walker, and Williamson. (Courtesy of Myrtice Chancey.)

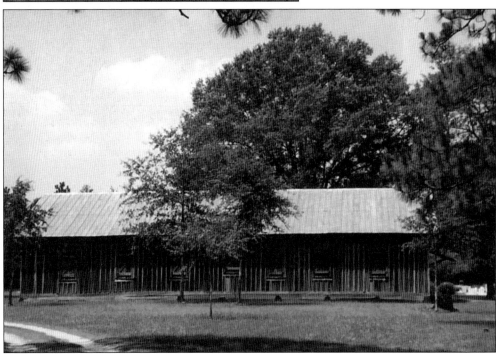

Another of Pierce County's oldest churches, Enon Primitive Baptist Church is located a few miles southeast of downtown Blackshear. Built in the same fashion as the Shiloh church, it also has a cemetery that includes members of such pioneer families as the Allens, Battens, Clarks, Cowarts, Dixons, Powerses, Shumans, and Walkers.

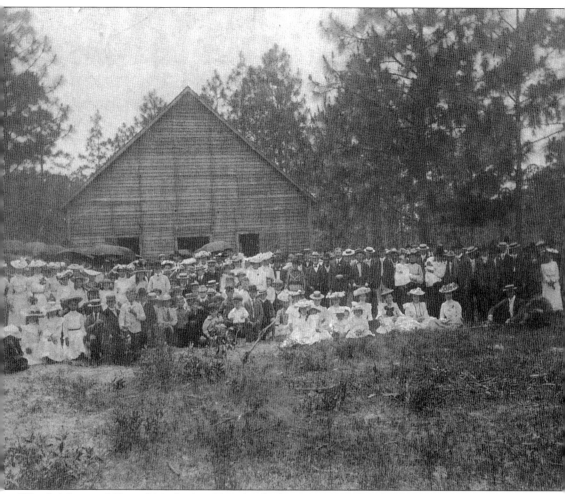

Ward's Memorial United Methodist Church, also known as Ward's Chapel, dates back to 1899, when it was founded by Mr. and Mrs. John O. Ward as a Sunday school. The church stands in the vicinity of the old Civil War prison camp on Highway 203. Mrs. Geraldine Summerall, who knew the history of the prison, was a devoted member of Ward's Chapel and played the piano there for over 70 years. Here, members of the congregation gather in the rain for this 1912 photograph. (Courtesy of Rubye Carter.)

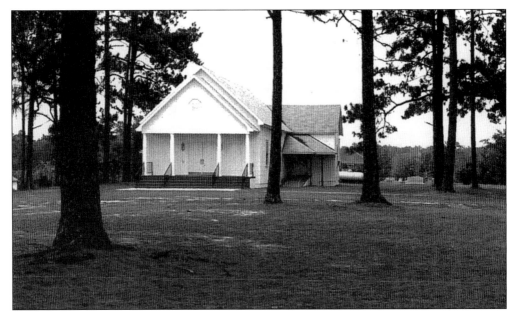

The Alabaha Free Will Baptist Church, the only church of its denomination in Pierce County, was established in 1906 about six miles west of Blackshear on Highway 203. John F. Knox gave the land for the church, and the deeds of the church property are dated March 5, 1904. In the rear of the church stands the cemetery, where, sadly, the first three individuals to be buried were infants. Those buried here belonged to such families as the Brewtons, Davises, Deloaches, Dixons, Easons, Harrisons, Robertses, Sapps, Sweats, Thrifts, Vanns, and Waldens.

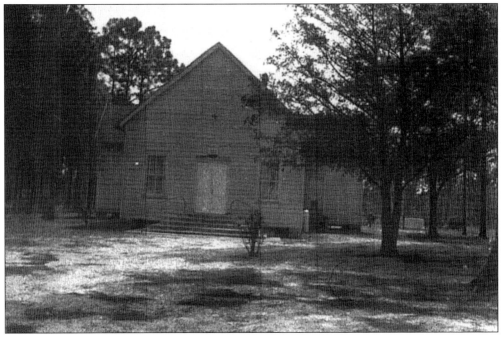

The founders of the Alabaha Free Will Baptist Church were D.L. Sapp, J.H. Sikes, and S.A. Brewton. Shown here early in its history, this church still opens its doors for worship service after nearly 100 years of existence. (Courtesy of Mildred Brewton Walker Dowling.)

Four
THRIVING COMMUNITIES

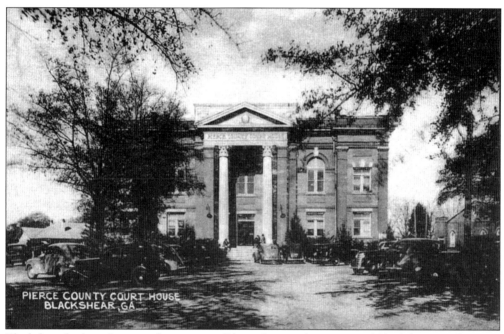

PIERCE COUNTY COURT HOUSE
BLACKSHEAR, GA.

Blackshear built its first courthouse, a small log cabin, in the vicinity of Blackshear Presbyterian Church. A second structure was built on the site where the Blackshear Drugstore later stood. Then, another more elegant courthouse was built in 1875 and stands in the park square today. At the turn of the 20th century, there was a need for a new and much larger courthouse as the previous one could no longer accommodate the growing legal business in the county. Pictured above is the Pierce County Courthouse as it appeared in the early 1900s. This magnificent structure is listed on the National Register of Historic Places. (Courtesy of the Pierce County Historical & Genealogical Society, Inc.)

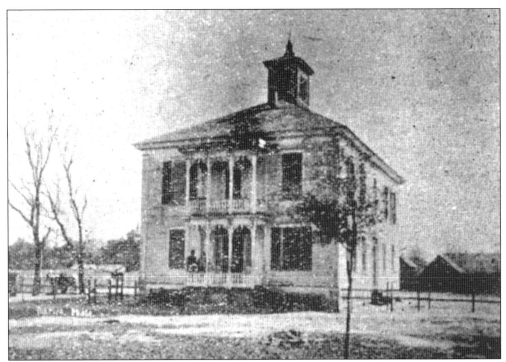

This beautiful antebellum-style courthouse, built in 1875, was the last wooden courthouse to serve the county before a new building was erected in 1902. Located on Park Street in the park square, this courthouse is now a private residence. (Courtesy of Ruth Hendry.)

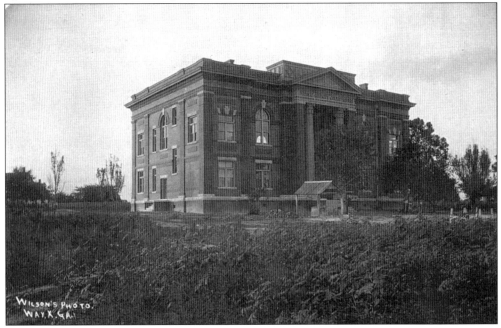

B.D. Brantley supervised the construction of the new courthouse at a cost of $23,000. On May 4, 1903, the county accepted the courthouse as the new judicial branch of operations for Pierce County. (Courtesy of the Pierce County Historical & Genealogical Society, Inc.)

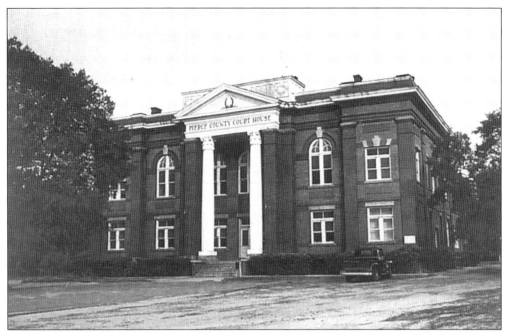

This photograph of the Pierce County Courthouse was most likely taken between 1950 and 1960 before the streets of the city were paved. (Courtesy of the Pierce County Historical & Genealogical Society, Inc.)

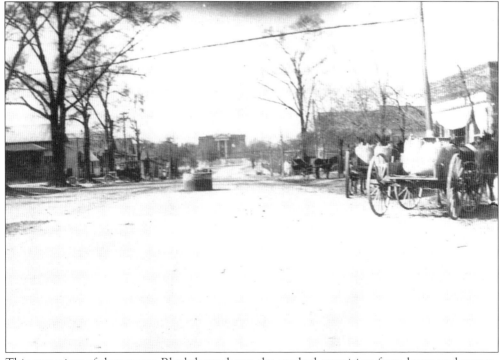

This rare view of downtown Blackshear shows the gradual transition from horse and wagon, evident on the right-hand side of the road, to the automobile, located down the street on the left. The Pierce County Courthouse is visible in the distant. (Courtesy of Bill Brown.)

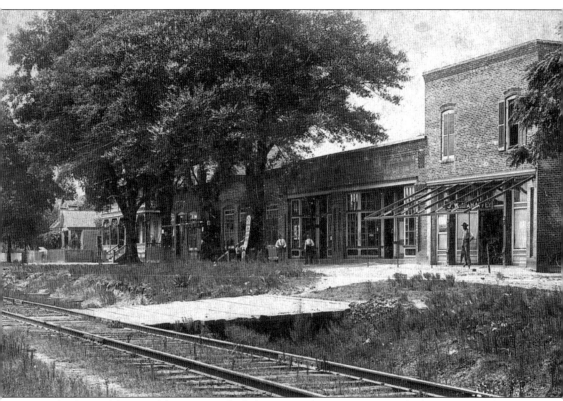

This beautiful view of downtown Blackshear was taken sometime in the late 1800s and captures some of the first buildings in the town, all of which were made of brick. The first business on the right was the store of J.W. Mahaffey. The two-story building on the far end was the popular Brown Hotel. It, along with all of these buildings, burned in 1899. However, the Armitage Block was rebuilt that same year and those buildings stand to this day. (Courtesy of the Pierce County Historical & Genealogical Society, Inc.)

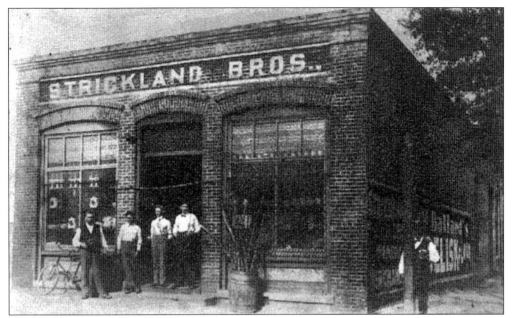

Strickland Brothers, founded in 1889, was a prominent business in downtown Blackshear. This was the first brick building in Blackshear and it stood on the corner of Main Street at the present site of Tony Batten's Men Shop. Those pictured include John A. Strickland, John F. Youmans, and Crawley Henderson. (Courtesy of Ruth Hendry.)

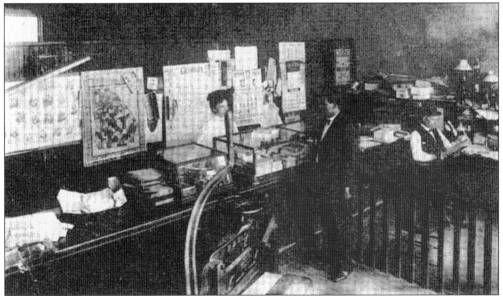

Blackshear got its first newspaper in 1870. Robert Burton became the proprietor of the *Southeast Georgian*, and the *Little Gem* was started by E.Z. Byrd on March 1, 1878. He eventually changed the paper's name to the *Blackshear News*. The *Blackshear Times* followed thereafter and began a long career starting here in the end building of the Armitage Block on October 10, 1889. In 1959 the *Blackshear Times* published its 100th Anniversary Historical Edition, a commemorative newspaper of 100 years of history of Pierce County. The *Blackshear Times* is the oldest newspaper in Pierce County. (Courtesy of Ruth Hendry.)

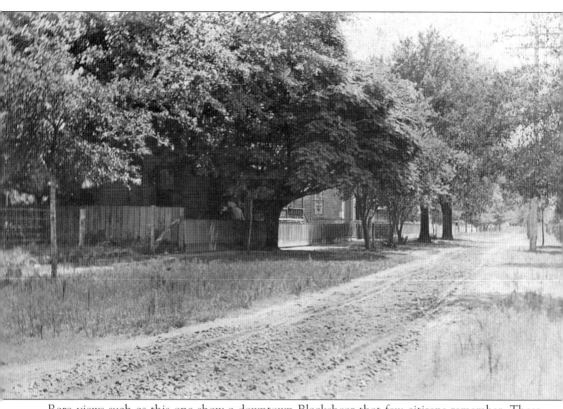

Rare views such as this one show a downtown Blackshear that few citizens remember. These sandy streets rutted with wagon tracks and shaded by towering oak trees remind one of Pierce County's earliest days. (Courtesy of the Pierce County Historical & Genealogical Society, Inc.)

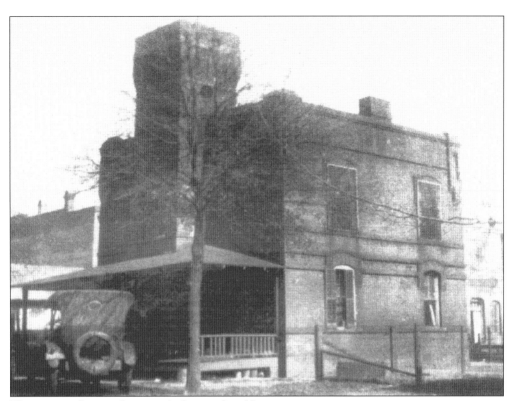

This extremely rare photograph depicts the old city jail, also known as the hanging jail, which was built in 1894. This jail replaced an older wooden jail, which had burned due to a fire caused by an inmate. The upstairs still contains two of the old cells that confined prisoners. Many local residents believed the tower in the center of the jail to be a scaffold where criminals were hanged. However, no one was ever hanged inside the jail. Robert Skellie, who murdered his wife with an iron stew pan and chair, is the only known criminal to be formally hanged in Pierce County. He was hanged on May 23, 1879, one-quarter mile southeast of town. The jail is listed on the National Register of Historic Places. (Courtesy of John Roberson.)

John W. Roberson, the sheriff of Pierce County in the early 1900s, was relentless in upholding the law. He is pictured here with several prizes from a recent arrest—an arsenal of shotguns and pistols lined up around a moonshine jug. On Tuesday afternoon, August 23, 1921, while tracking an escaped convict three miles west of Patterson, Sheriff Roberson was shot and killed. He left behind a wife and ten children. (Courtesy of John Roberson.)

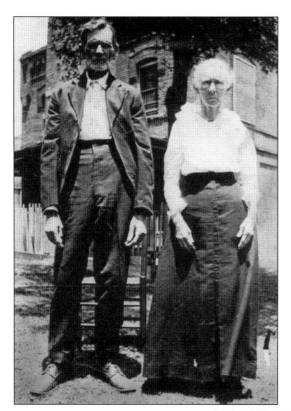

James Yarbrough

The ~~Westberrys~~ pose for a photograph in front of the old city jail in Blackshear. This is one of the rarest photographs of the old jailhouse. The fence was later removed from around the building, but the structure remains a truly unique work of architecture in Blackshear. (Courtesy of Geraldine Summerall.)

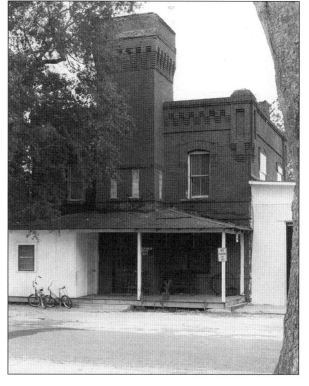

Another view shows the old jail during the 1970s. By this time, the jail was only used as a dispatch office by the Blackshear Police Department and a storage facility for impounded evidence. A much larger jail was built in front of the courthouse in 1926 but was torn down in 1999. The Blackshear Fire Department was built onto the right side of the jailhouse in the 1960s. (Courtesy of the Pierce County Historical & Genealogical Society, Inc.)

Sheriff Roberson consistently scoured the county in search of criminals, especially moonshiners. Moonshining was an ongoing problem all over Southeast Georgia as well as in the rest of the country. Here, Sheriff Roberson (center) stands with two of his deputies and confiscated weapons from a still they captured in the woods in Pierce County. (Courtesy of John Roberson.)

A.P. Brantley & Company was the new name of the family business created by A.P. Brantley after his father's death in 1891. The Brantley family soon built a large Sea Island cotton gin, and Blackshear became one of the largest Sea Island cotton markets in the world. (Courtesy of the Pierce County Historical & Genealogical Society, Inc.)

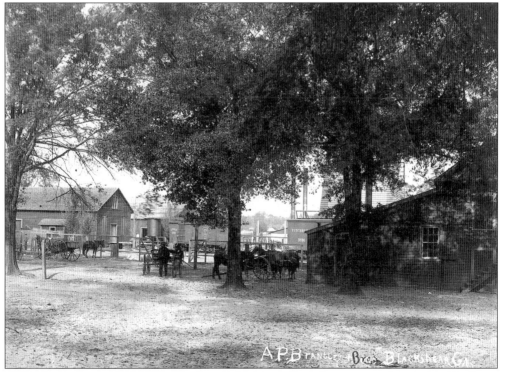

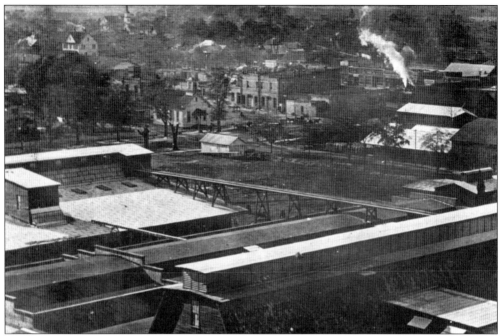

This is probably the oldest aerial view of downtown Blackshear in existence; it was taken in the early 1900s. In the foreground is the major plant operation the Brantley family established, helping to put Blackshear on the map. This photograph was most likely taken from the water tower. (Courtesy of the Pierce County Historical & Genealogical Society, Inc.)

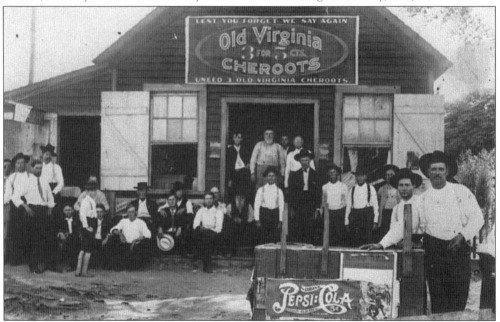

Local men stand in front of Tom Woods Store, a small but profitable business along Main Street in Blackshear during the early 1900s. The store stood on the site of what is today the People's Bank. The People's Bank, established in 1946, is still a major financial institution in Pierce County. (Courtesy of Myrtice Chancey.)

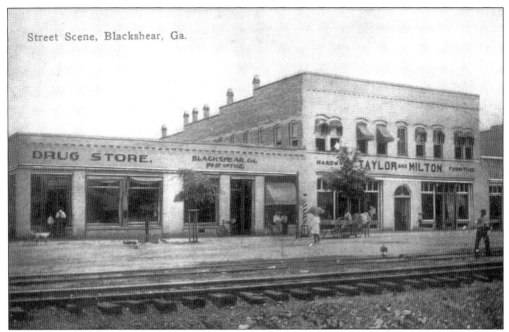

Downtown Blackshear continued to grow with buildings such as these located on South Central Avenue. A drugstore, the post office, and Taylor and Milton were occupants for many years. Dr. W.N. Brown's dentist offices was located upstairs. (Courtesy of the Pierce County Historical & Genealogical Society, Inc.)

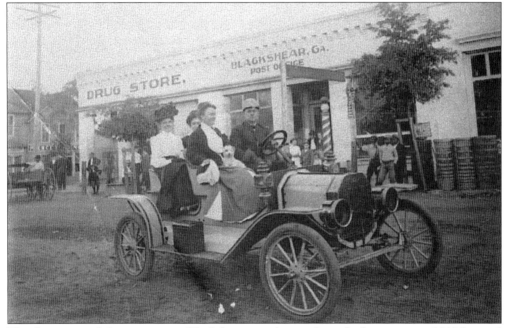

The first automobile to arrive in Blackshear was driven through the streets in 1910 by mail carrier Jeff Allen. The second car in the county was known as the "Invincible" Schacht Runabout. It cost $680. In time, the newly invented automobile became more common on the sandy streets of Blackshear and Pierce County. (Courtesy of Ruth Hendry.)

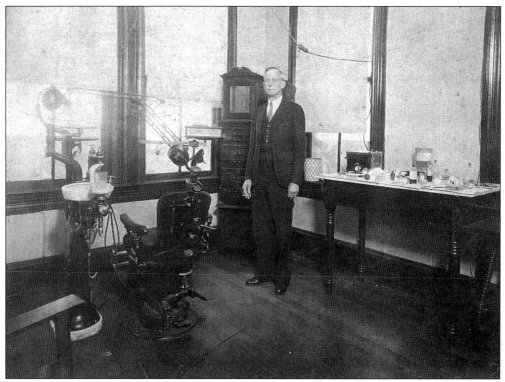

Dr. W.N. Brown was the second generation of the Brown family to practice dentistry in Blackshear. His son, William G. Brown, became the third generation in dentistry and served on the Board of Dental Examiners of Georgia. (Courtesy of Bill Brown.)

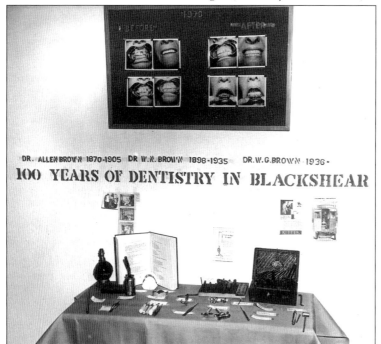

The Brown family celebrates 100 years of dentistry in Blackshear. Phillip Brown, the fifth generation of the Brown family, would become a chief surgeon, establishing his practice in Thomaston, Georgia in 2000. (Courtesy of Bill Brown.)

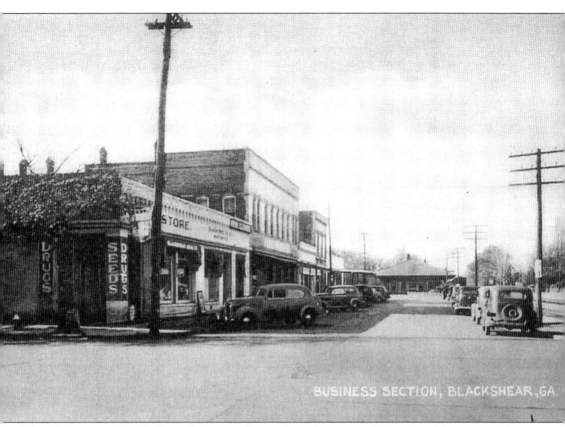

This 1940s view of South Central Avenue shows a busy downtown. The railroad depot is visible in the distant. (Courtesy of the Pierce County Historical & Genealogical Society, Inc.)

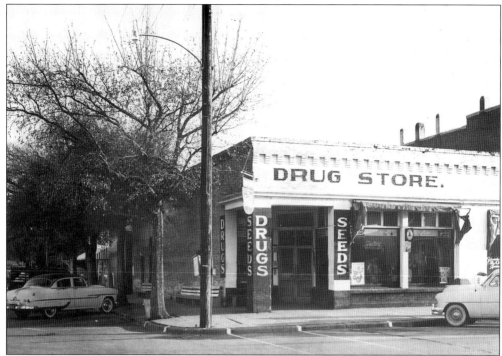

This was one of several drugstores that occupied the corner of Main Street and South Central Avenue in downtown Blackshear. (Courtesy of the Pierce County Historical & Genealogical Society, Inc.)

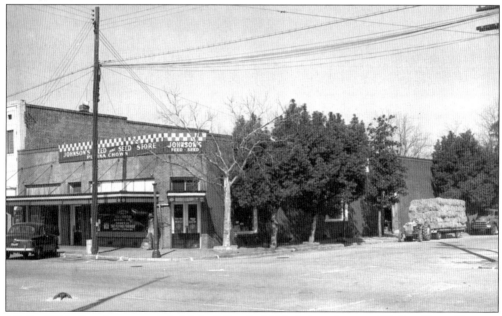

J.F. Ratliff & Son first occupied this building in 1911. It later became Walker Bros. Grocery; Johnson's Feed and Seed Store followed thereafter. Johnson's was a bustling place of business where farmers would come to pick up supplies, feed for their livestock, and seed to plant their next season's crop. (Courtesy of the Pierce County Historical & Genealogical Society, Inc.)

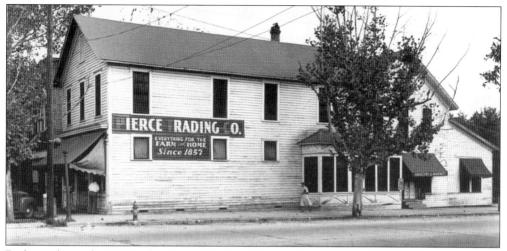

Built in the early 1900s, the Pierce Trading Company, which once stood on the northern corner of Main Street and Central, served local residents' dry goods and grocery needs until 1949. (Courtesy of the Pierce County Historical & Genealogical Society, Inc.)

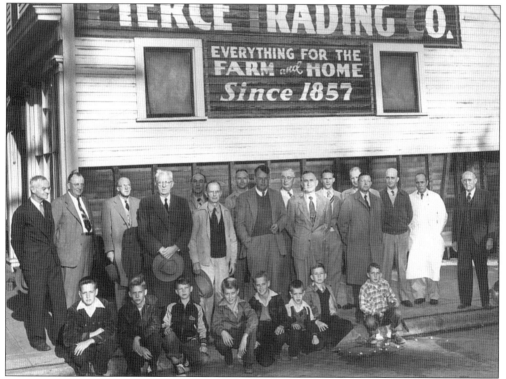

The men of the Pierce Trading Company in Blackshear are, from left to right, (standing) Col. Warren Lott, Paul Morgan, Leo J. Allen, J.H. Donaldson, J.W. Newton, Ben M. James, Aubrey Geiger, George D. Brantley, W.C. Fleming, George D. Walker, M.C. McAlpin Jr., Fred Hobbs, R.D. Thomas, Arthur Lee Howard, J.E. Crawford, and Herman Summerall; (kneeling) George D. Brantley Jr., Kenneth McAlpin, Ben L. Donaldson, Ben M. James Jr., Edgar Brantley, Duncan Brantley, George D. Walker Jr., and R.D. Thomas Jr. (Courtesy of the Pierce County Historical & Genealogical Society, Inc.)

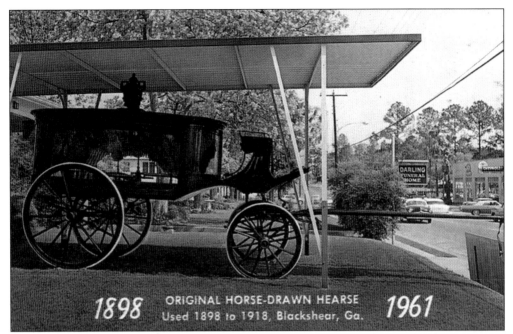

1898 ORIGINAL HORSE-DRAWN HEARSE 1961
Used 1898 to 1918, Blackshear, Ga.

Begun in 1892 by E. Lee Darling, the Darling Funeral Home assisted many families preparing funeral arrangements for their loved ones. This horse-drawn hearse was traded in for a Model T ambulance in March 1918. The business was later sold along with this priceless hearse. (Courtesy of the Pierce County Historical & Genealogical Society, Inc.)

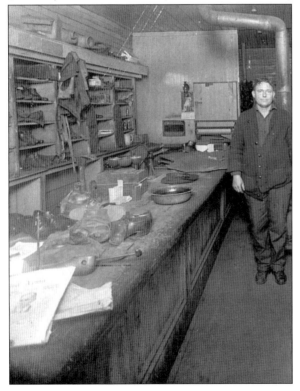

Benjamin Martin Peacock owned this shoe store, which was located in the Armitage Block in downtown Blackshear. He married Georgia Kirby and they had three children, Huel, Mildred, and Anne. Peacock later moved on to Texas by himself. (Courtesy of Huel Walker.)

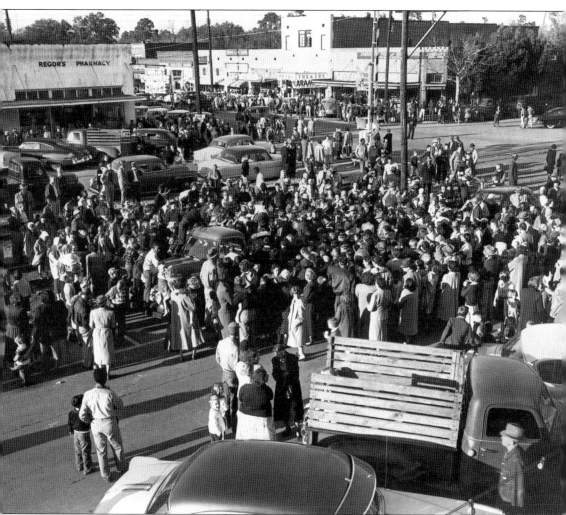

One of the most celebrated events in Pierce County is Christmas. Businesses decorate their storefronts, sidewalks are filled with shoppers, and, of course, Ole St. Nick makes his annual visit. Here, he appears to have another means of transportation besides Rudolph and company to assist him in handing out candy and gifts to the local children. Also in this photograph is a rare view of the Royal Theater, which for many years was a popular place for young people to see movies. It is the two-story building in the distant background on the right side of Main Street. (Courtesy of the Pierce County Historical & Genealogical Society, Inc.)

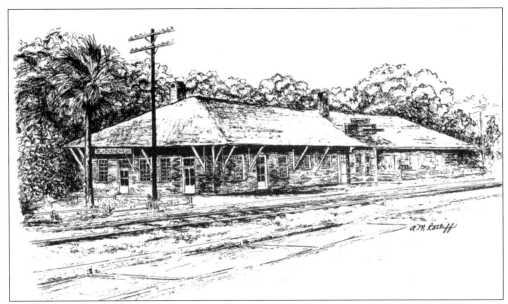

Local artist Alvin Ratliff drew this beautiful piece of art depicting the historic 1902 Blackshear Railroad Depot. (Courtesy of the Pierce County Historical & Genealogical Society, Inc.)

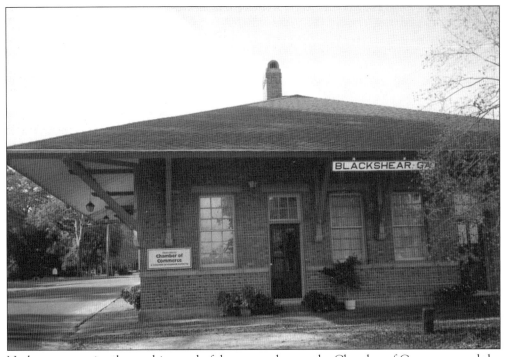

No longer an active depot, this wonderful structure houses the Chamber of Commerce and the Pierce County Historical & Genealogical Society's Genealogical Library and Heritage Museum. Built in 1902 to replace a previous wooden depot that burned in 1892, this building was placed on the National Register of Historic Places in 2000. (Courtesy of the Pierce County Historical & Genealogical Society, Inc.)

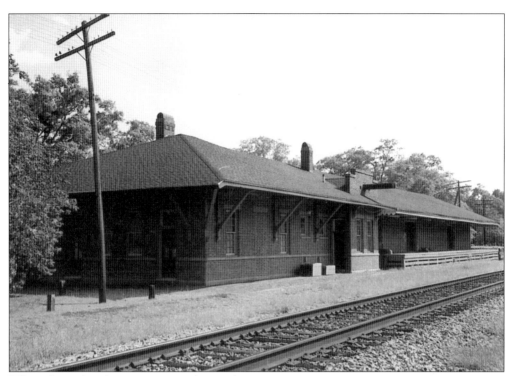

When the earlier depot, constructed entirely of wood, burned on January 10, 1892, there were a large number of hogs consumed in the fire. These animals had made their home underneath the loading dock. This brick depot was built to accommodate more freight and an increased number of passengers who were traveling through Blackshear. (Courtesy of the Pierce County Historical & Genealogical Society, Inc.)

Mack Bennett worked at the Blackshear Railroad depot for many years, handling freight and luggage for the passengers arriving and departing. In 1902, there were seven passenger trains a day and a steady freight service. (Courtesy of the Pierce County Historical & Genealogical Society, Inc.)

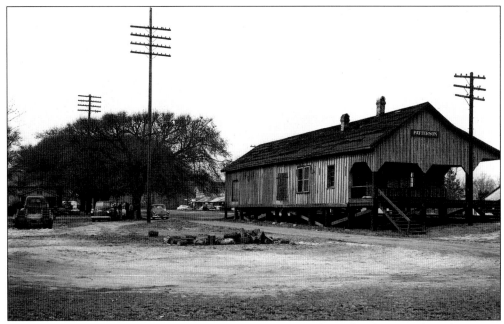

As fewer and fewer stops were made along the route of travel, smaller depots such as this one in Patterson were closed down. A private citizen purchased the depot from the city and transported it onto his property on the northwest end of the county. He later cut the building in half and converted it into a private residence. (Courtesy of the Pierce County Historical & Genealogical Society, Inc.)

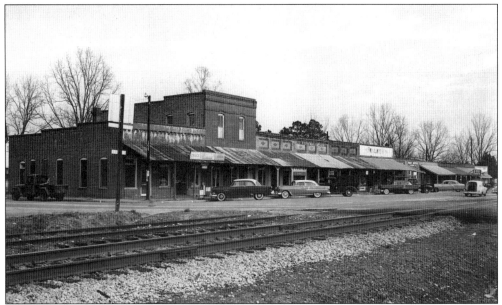

From 1880 to 1919, Patterson was a vibrant little area of commerce for the local citizens. A livery stable, general store, drugstore, blacksmith shop, sawmills, and other businesses were present along the railroad line, but the lack of local industry forced many to move to larger communities, leaving the streets of Patterson almost silent. (Courtesy of the Pierce County Historical & Genealogical Society, Inc.)

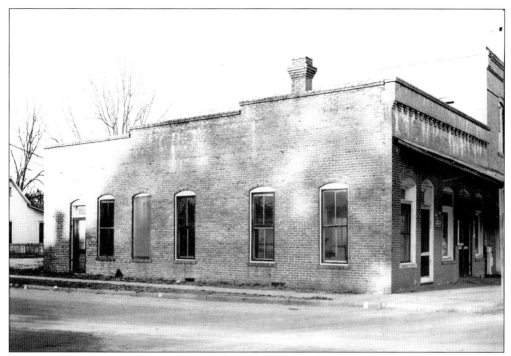

This building stands on the corner of Highway 203 and Railroad Avenue. It was once the office of Dr. Charles S. New, a doctor who cared for many of the people of Patterson. (Courtesy of the Pierce County Historical & Genealogical Society, Inc.)

The citizens of Pierce County have always taken great pride in their towns. Here, the residents of Patterson hold a rally to clean up their community. (Courtesy of the Pierce County Historical & Genealogical Society, Inc.)

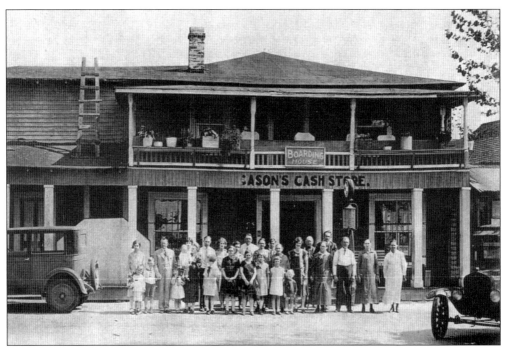

With the establishment of a post office in August 1887 and the Southern Pine Company, Cason's Cash Store and Boarding House became one of the many early flourishing businesses in Offerman. But when the timber industry folded in the area, so did Cason's store. (Courtesy of Mina Aspinwall.)

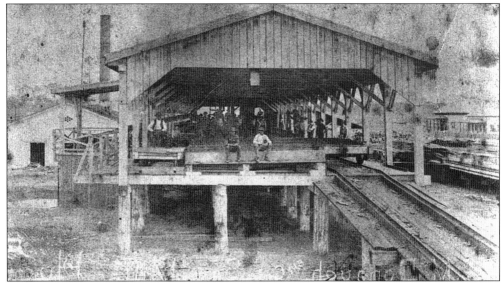

The Atlanta, Birmingham & Coast (AB&C) Railroad and Plant Railroad Systems (later Atlantic Coast Line) reached Offerman as a result of the prosperous timber industry, and the Southern Pine Company built sawmills such as this one. The company shut down in 1905 and the tracks ceased to be an active railroad system. Today, however, the timber industry is thriving once again and the Gilman Company is the major sawmill in the county. (Courtesy of Ruth Hendry.)

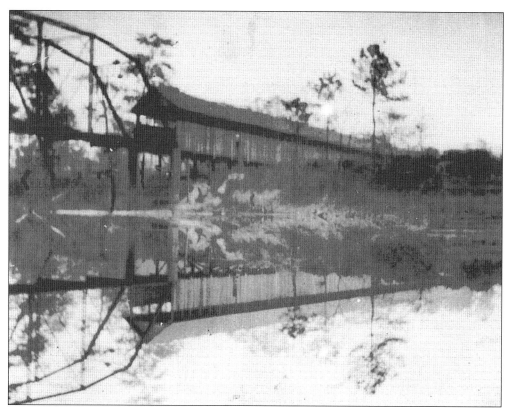

Built in 1909, this beautiful covered bridge stood over the Satilla River connecting Pierce County to Ware County. (Courtesy of Lucile Walker Miller.)

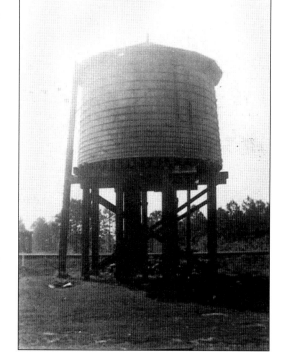

This water tower in Offerman may very well have witnessed President Franklin Roosevelt's stopover to refuel his train. He was traveling on his way to Washington from Warm Springs. One young girl recalled that the president waved to the crowd of locals from his window while he was waiting. This water tower is no longer standing. (Courtesy of Ethel Roberson.)

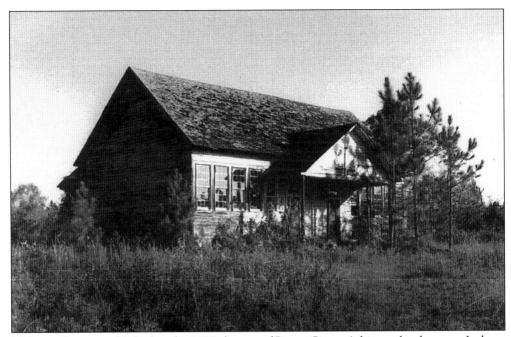

Walkerville was established in the 1890s by one of Pierce County's biggest landowners, Jackson Walker. He owned over 5,000 acres of land in the northwest part of the county and developed a sawmill, turpentine still, commissary, eight cotton gins for Sea Island cotton, and the elementary school, seen above, for the children of the area. A post office was established in 1895, and Will Smith, a local blacksmith, became the postmaster. The community of Walkerville is all but a memory now. Two dilapidated structures—this schoolhouse and the commissary—are all that remain. (Courtesy of the Pierce County Historical & Genealogical Society, Inc.)

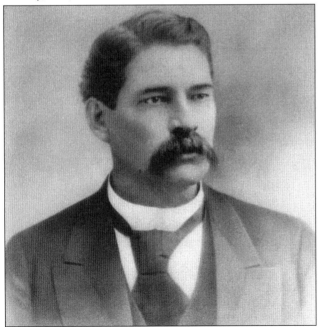

John Mershon was a distinguished lawyer and judge in Pierce County. The small community of Mershon, northwest of Blackshear, arose out of the growth of the railroad, which ran from Offerman to Nichols. The town was named Mershon in this man's honor. (Courtesy of Ruth Hendry.)

Five
CORNERSTONE OF
AN ECONOMY

Pierce County's development began as a result of the timber industry. The Southern Pine Company built profitable sawmills around the Offerman and Patterson area. Today one can drive for miles and still see long rows of tall lush pines. Today, the Gilman Company is the most prominent timber business in Pierce County, as well as in South Georgia. (Courtesy of the Pierce County Historical & Genealogical Society, Inc.)

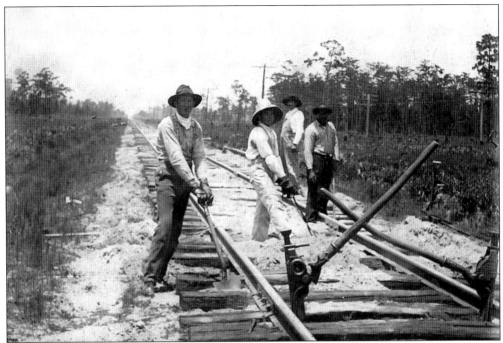

There have been five railroad lines built through Pierce County. The Atlantic and Gulf Railroad played a vital role in the prosperity of the towns throughout the county. It was completed to Blackshear on May 1, 1859, and allowed many citizens their first glimpse of the "iron horse." Union prisoners of war arrived by rail, and many dignitaries passed through, including former President of the Confederacy Jefferson Davis on his way home to Mississippi. Here, Oscar Thrift and Art Dowling work at repairing the railroad. (Courtesy of Huel Walker.)

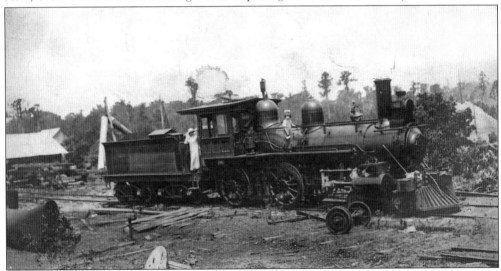

This photograph showing a woman and little girl standing on an old train may very well have been taken near Offerman during the prosperous time of the sawmills. At one time there were two railroads, the AB&C and the Atlantic and Gulf Railroad, which intersected in Offerman to transport the mass quantity of wood being generated. When the sawmills folded, the tracks were no longer of service. (Courtesy of Huel Walker.)

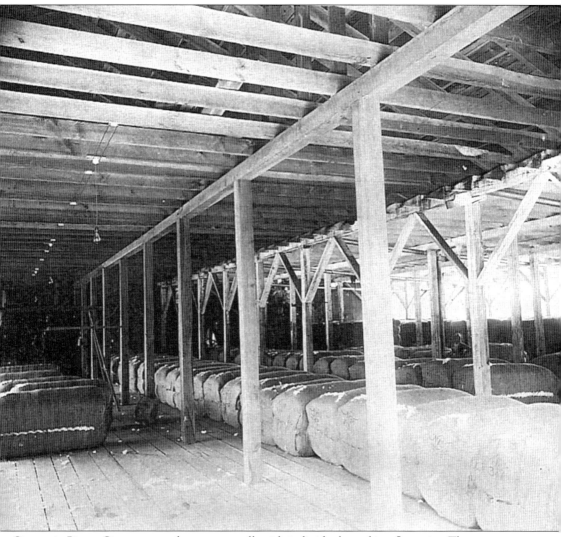

Cotton in Pierce County started out very small, with individuals working floor gins. The cotton was then gathered and taken by wagon to coastal towns such as Darien and St. Marys and sold for 25¢. Cotton productivity eventually increased and a local market began to form. Here, the Brantley Warehouse is fully stocked with bales of cotton ready for the market. After the boll weevil destroyed cotton crops, warehouses made the transition from their floors being filled with cotton bales to sheets of tobacco. (Courtesy of the Pierce County Historical & Genealogical Society, Inc.)

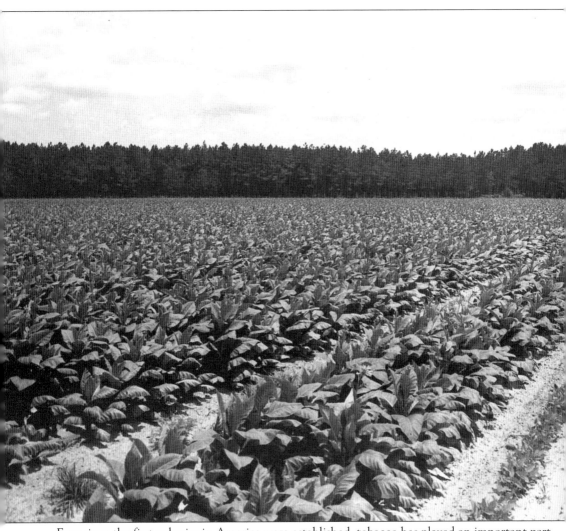

Ever since the first colonies in America were established, tobacco has played an important part in the agricultural economy. Tobacco was introduced to Pierce County when it was first settled; however, it was not until the early 1900s that tobacco became the leader of the county's local economy. (Courtesy of Pierce County Historical & Genealogical Society, Inc.)

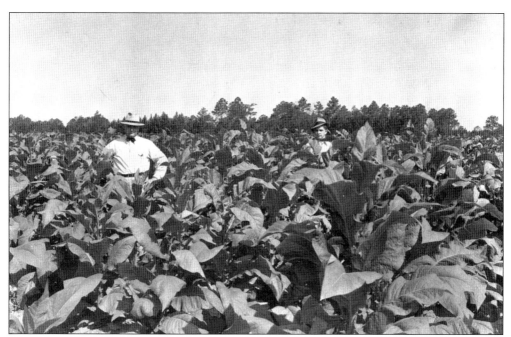

Most farmers in the county depended on tobacco as their major crop, and throughout the area, one could see tobacco fields spanning across entire farms. Today, the industry has diminished, but the golden leaf remains as an important crop to many farmers. (Courtesy of the Pierce County Historical & Genealogical Society, Inc.)

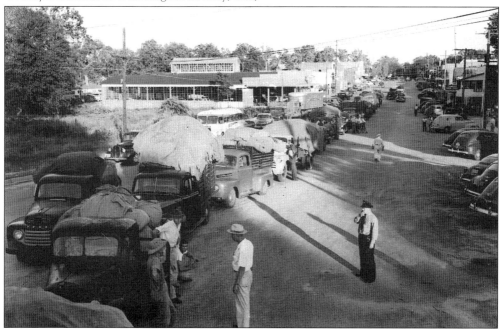

When it was time for the farmers to bring their tobacco to market long lines of fully loaded trucks and trailers stretched for miles throughout Blackshear, a major center for the Southeast Georgia tobacco market. The Brantley Brick, Big Z and Planters, and Farmer's Warehouses #1 and #2 were filled with the aroma of the golden leaf. (Courtesy of Ruth Hendry.)

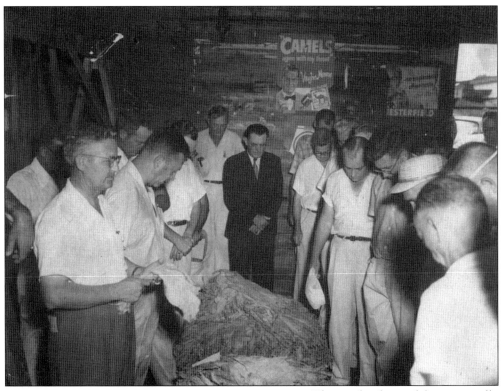

The inside of one of the more well-known tobacco warehouses, the Big Z and Planters, is depicted here. The first sell of the season was typically opened with a prayer by the local minister. The two men on the left are Mack Carter Sr. and Paul Edmonds. (Courtesy of Ruth Hendry.)

The original owners of the Big Z and Planters Warehouse were Ben Hawthorn, Mack Carter, and Paul Edmonds. Alvin Walker Jr., Jay Davis, and Joe Boyett would be the next generation to take over the Big Z and Planters warehouses and carry on the tradition. (Courtesy of Mack Carter Jr.)

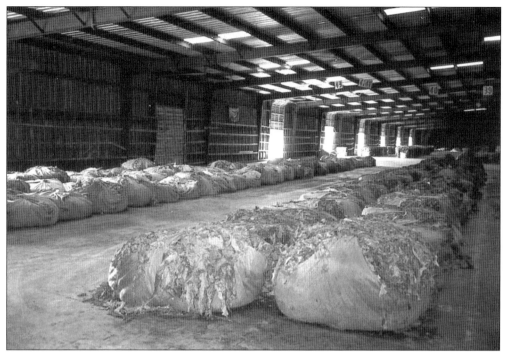

Even in the 21st century, long rows of tobacco sheets can be seen throughout the Big Z and Planters Warehouse. (Courtesy of John Guss.)

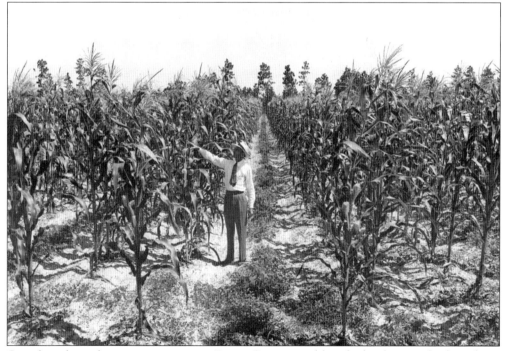

Corn has always been a major crop in Pierce County, and hundreds of acres of it have been cultivated since the 1850s when the county began. (Courtesy of the Pierce County Historical & Genealogical Society, Inc.)

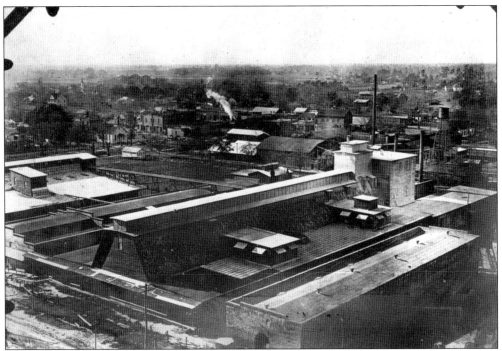

The Blackshear Manufacturing Fertilizer Plant was another industry established in Blackshear. (Courtesy of the Pierce County Historical & Genealogical Society, Inc.)

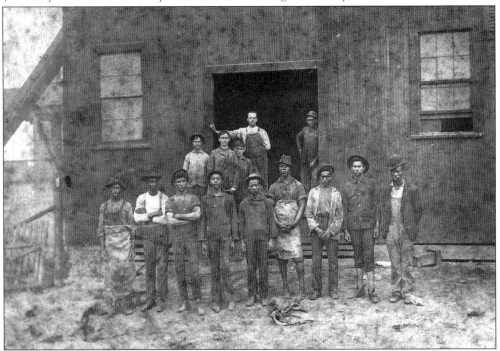

Not everyone farmed in Pierce County. Some men came to Blackshear to work for the Brantley Company. These factory workers helped build that company. (Courtesy of the Pierce County Historical & Genealogical Society, Inc.)

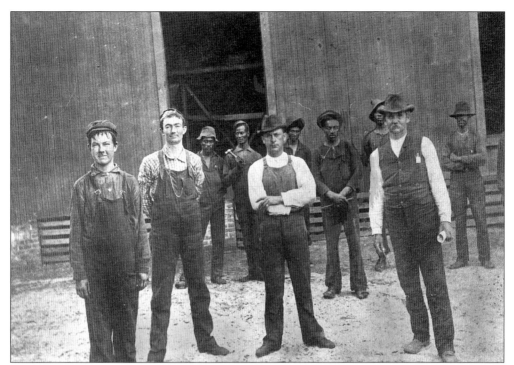

This is another photograph of factory workers at the Brantley Company. In the foreground are, from left to right, Will Sweat, T.C. Sauls, R.W. Belvin, and John C. Jones. (Courtesy of the Pierce County Historical & Genealogical Society, Inc.)

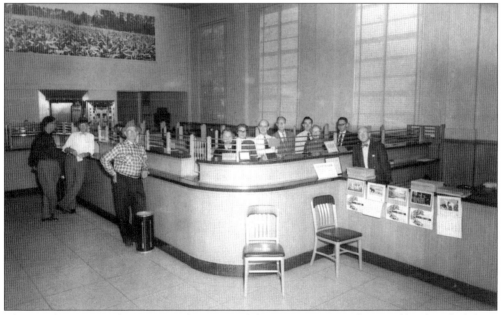

Chartered on September 11, 1891 by an act of the Georgia General Assembly, the Blackshear Bank is the oldest financial institution in Pierce County. More widely known as Prime South, the first bank retains its original name. (Courtesy of the Pierce County Historical & Genealogical Society, Inc.)

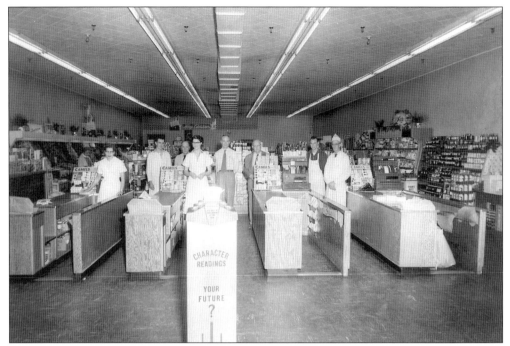

The Pierce Trading Company provided many residents with their grocery and dry goods needs. From left to right are Mae Crews, Emory Baggs, Jesse Crawford, Rosa Belle Hodges, manager Aubrey Geiger, Herman Summerall, Clyde Harris, and Corbitt Cochran. (Courtesy of the Pierce County Historical & Genealogical Society, Inc.)

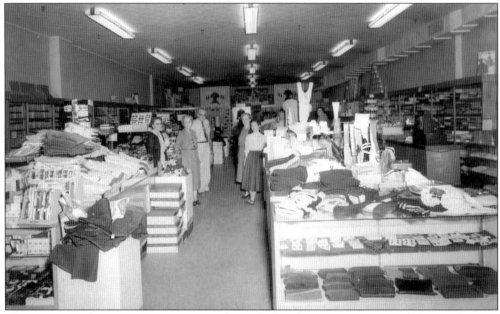

The Pierce Trading Company was quite diversified with a grocery store and dry goods store. Here the staff poses in a well-stocked store. From left to right are Mable J. Bennett, Mary Hyatt, manager Mr. Randall, Nancy Spell, and Pearl P. Bowen. (Courtesy of the Pierce County Historical & Genealogical Society, Inc.)

Six

EDUCATION

BLACKSHEAR ACADEMY,

REPORT OF

Nettie Brantley,

For the Week ending *Oct. 26* 188_

STUDIES.	GRADE.	STUDIES.	GRADE.
Algebra	*95*	Geometry	
Application	*100*	History	*100*
Arithmetic	*100*	Latin	*90*
Attendance	*100*	Reading	
Composition		Spelling	*98*
Deportment	*100*	Writing	*100*
French	*95*	No. Days Late	
German		No. Times Absent	
Grammar	*100*	General Average	*98*
Geography		No. Pupils in Class	*6*
Greek		Relative Standing	*1*

100 is Perfect; 80, Good; 70, Passable, and 0, Failure.

The parent is requested to examine this report closely, and is earnestly urged to co-operate with the teacher in increasing the interest and improving the grade of the pupil. Please sign and return.

(Name of Parent.) *B. J. Brantley*

In its earliest days, Pierce County had a difficult time finding teachers for its schools. In 1850, one unidentified man wrote, "All was ever asked of someone was if they could read, write, and cipher. If they said they could, they were all right to teach." Some 30 schools were eventually established throughout the county to accommodate children who could not come to town. Gradually, education improved and children were given "marks" for their work. This report card belonged to Miss Nettie Brantley when she attended the Blackshear Academy in the 1880s. (Courtesy of the Pierce County Historical & Genealogical Society, Inc.)

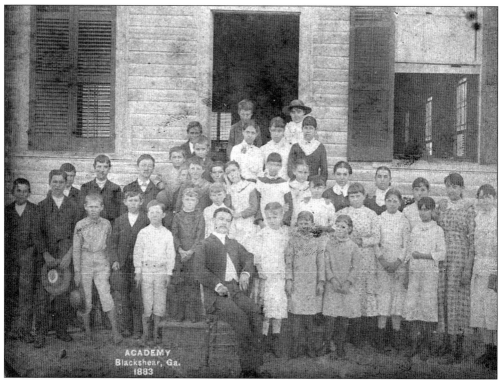

This is one of the oldest photographs of a Pierce County schoolhouse and it depicts Blackshear Academy in 1883. (Courtesy of Huel Walker.)

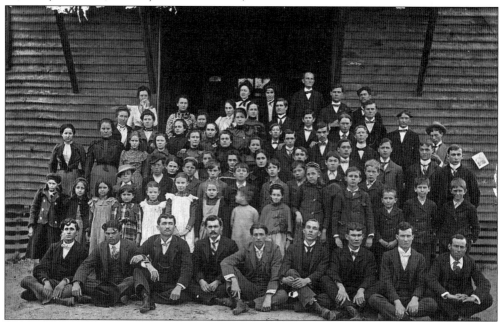

Pierce County Normal School was another school in the county where children who lived outside Blackshear could receive an education. (Courtesy of the Pierce County Historical & Genealogical Society, Inc.)

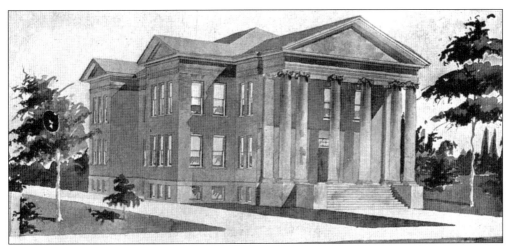

Plans for the most sophisticated educational institution in Pierce County were made a reality when the Savannah Presbytery built an elaborate campus. This is a painting of the proposed main building for the Presbyterial Institute. Obviously, it was quite different upon its completion. (Courtesy of the Pierce County Historical & Genealogical Society, Inc.)

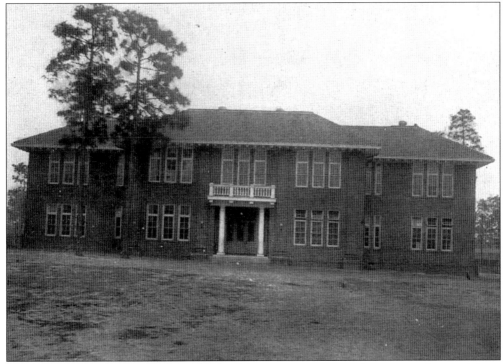

This is the main building of the Presbyterial Institute as it appeared upon completion. It later served as the Pierce Collegiate Institute until 1917, when it became Blackshear High School. (Courtesy of the Pierce County Historical & Genealogical Society, Inc.)

ORIGIN AND PURPOSE.

The Presbyterial Institute was founded by the Presbytery of Savannah and is under control of a Board of Trustees elected by that presbytery ; but generous contributions from men of all the denominations of this section have made it possible to begin under very favorable circumstances. It is in no sense for gain, but is intended to afford thorough education at the lowest possible cost to every boy and girl in South Georgia.

It is the purpose of the school to take children of both sexes from the earliest school age and give them a thorough fitting for college or practical life. As character is the foundation of all greatness, the Institute seeks to develop cultured minds and strong moral character. The Bible is the foundation on which true character rests and in the Institute it will be a constant text-book. While entirely free from *sectarian bias* the school is nevertheless distinctly *Christian*, and it is the earnest desire and purpose of the Institute to improve the moral and spiritual tone of its students as well as to cultivate the mind.

EQUIPMENT AND MANAGEMENT.

The main building is a large structure with five class-rooms, two music-rooms, a parlor, and rooms for a matron, three teachers and sixteen girls. Girls from a distance will board here, but boys will, for the present, board in the homes of Blackshear. Present indications point to the fact that our accommodations will be taxed to the utmost, but as occasion demands we propose

The purpose of this institution was to develop young people into well-educated Christian-minded citizens. (Courtesy of the Pierce County Historical & Genealogical Society, Inc.)

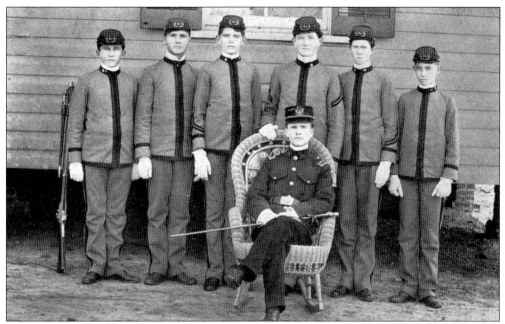

Maj. William G. Martin served as the commandant of the Presbyterial Institute. Some of the young men who attended the school were given military instruction; they became known as the Georgia Cadets. The Savannah Presbytery operated the Presbyterial Institute from 1901 to 1914. (Courtesy of the Pierce County Historical & Genealogical Society, Inc.)

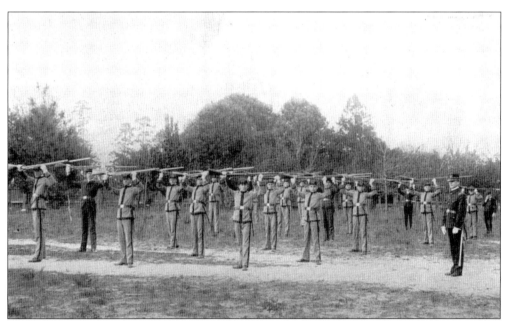

These cadets, dressed in fine uniforms, conduct bayonet drill exercises on the campus grounds. (Courtesy of the Pierce County Historical & Genealogical Society, Inc.)

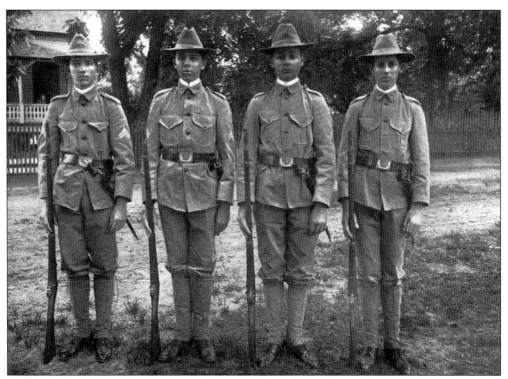

These young cadets pose for a photograph in their summer khaki uniforms. (Courtesy of the Pierce County Historical & Genealogical Society, Inc.)

MILITARY DEPARTMENT

A THOROUGH course in military tactics is given in the School of the Company, both in close and extended order; special attention is paid to the "setting-up" and bayonet exercises. The boys are kept under strict military discipline, and the training which they receive is excellent. A military training insures system in all things, forms habits of prompt obedience, personal neatness, and gives a true conception of duty and the responsibilities of life.

Each student is required to have one winter uniform and one summer uniform. These uniforms can be secured through the school at a cost of $14.00 and $6.00 respectively.

COMPANY ORGANIZATION

W. S. Gailliard, Commandant

STAFF OFFICERS

Harry Sheppard, Adjutant

Holmes Roberson, Quartermaster-Sergeant

Alvin Skinner, Musician

OFFICERS

Alex Cromartie, Captain

LIEUTENANTS

Archie McEachern	Clark Houk

SERGEANTS

Geo. C. Post	Tracy Olmstead
Emmerson Stewart	Grady Mills

CORPORALS

Ed. Jordan	Jno. Ward
Timmons Cockfield	Fred Cody

The military is often an important aspect of an educational institution, promoting discipline, dedication, and responsibility. (Courtesy of the Pierce County Historical & Genealogical Society, Inc.)

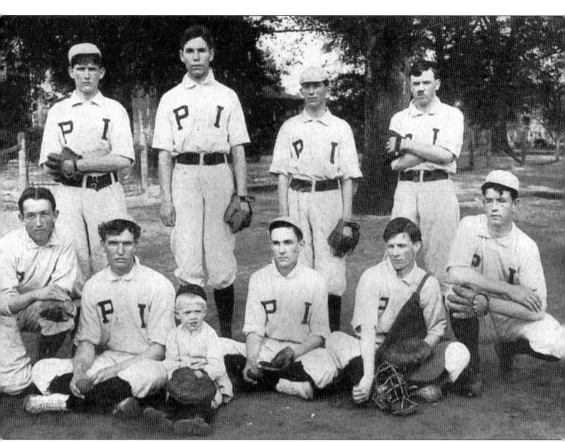

These young men played for the 1905–1907 Presbyterial Institute baseball team. From left to right are (front row) unidentified, a Cromartie, Giles Sydnor, S. Thomas Memory, Major Brown, and Broadus Estes III; (back row) Major Gaillard, commandant, unidentified, and Harry Sheppard. (Courtesy of the Pierce County Historical & Genealogical Society, Inc.)

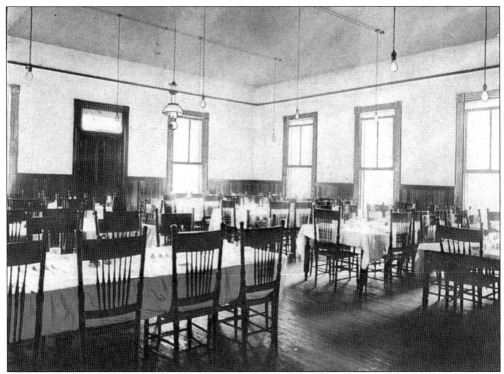

Students and professors gathered in this dining room to enjoy their daily meals and share in conversation. Students also learned to practice proper table manners, which was another aspect of their refinement. (Courtesy of the Pierce County Historical & Genealogical Society, Inc.)

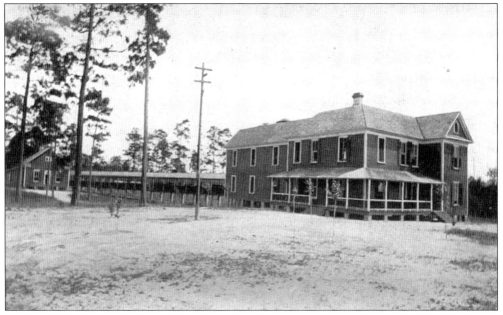

This photograph shows the main portion of the campus after it was first built. Included are the dining hall, covered walkway, and Williams Hall. (Courtesy of the Pierce County Historical & Genealogical Society, Inc.)

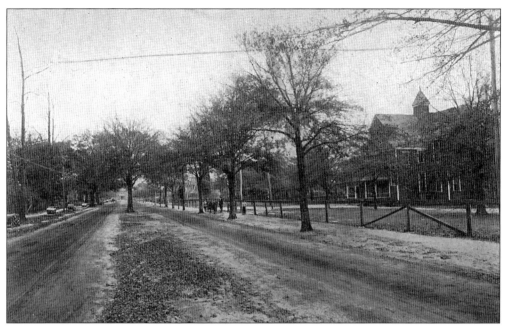
This is a rare photograph of Main Street and Gordon Hall. (Courtesy of the Pierce County Historical & Genealogical Society, Inc.)

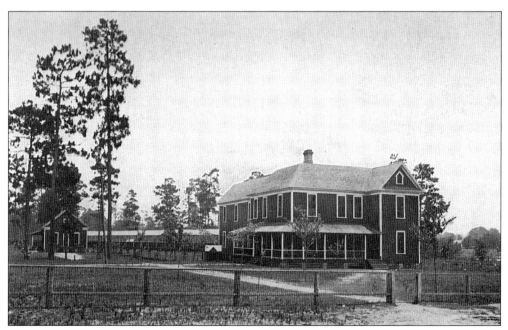
Here is a later view of the campus of Presbyterial Institute, which includes Williams Hall and the dining room. (Courtesy of the Pierce County Historical & Genealogical Society, Inc.)

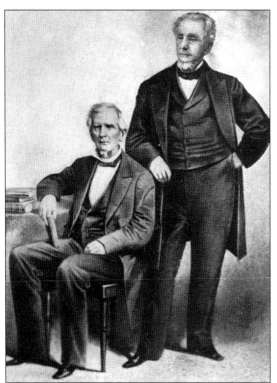

Dr. Lovick Pierce and Bishop George F. Pierce, depicted in this painting, were instrumental in the formation of the Pierce Collegiate Institute on September 10, 1913. The school was named in honor of George Pierce. The South Georgia Methodist Conference was given the buildings and the equipment from the Presbyterial Institute by the Savannah Presbytery in 1913. (Courtesy of the Pierce County Historical & Genealogical Society, Inc.)

Rev. W.A. Huckabee served as the first president of the Pierce Collegiate Institute in 1913–1914. (Courtesy of the Pierce County Historical & Genealogical Society, Inc.)

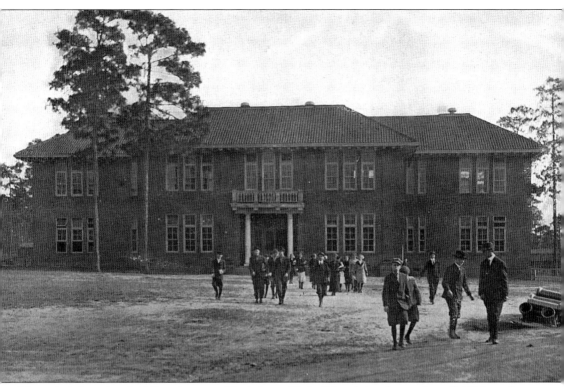

The administrative building became Blackshear High School in the spring of 1917 and remained as such until 1980 when Blackshear High School and Patterson High School combined to become Pierce County High School. It is the only building still standing of the Presbyterial Institute and Pierce Collegiate Institute. (Courtesy of the Pierce County Historical & Genealogical Society, Inc.)

HISTORY

The Blackshear Presbyterial Institute was founded in 1901, and was conducted by the Presbyterians for eleven years. In 1913, by order of the South Georgia Annual Conference, the school was purchased by the Methodists of the Waycross District.

LOCATION

WHERE TO COME

Blackshear is a beautiful town of nearly two thousand inhabitants, located in Pierce County, on the Atlantic Coast Line Railroad, ten miles North of Waycross. It is said to be the highest point between Savannah and Jacksonville, being about midway between the two cities. There are four passenger trains each way daily.

MORAL SURROUNDINGS

CHURCHES

There are five churches in Blackshear—two Methodist, one Presbyterian, one Missionary Baptist and one Primitive Baptist, and four Sunday Schools. No people have higher moral ideals than the citizens of Blackshear.

MINISTERS

The following are the pastors of the above churches: Rev. W. A. Brooks and E. M. Sanders, Methodists; Rev. A. L. Patterson, D. D., Presbyterian; Rev. J. P. McGraw, Missionary Baptist; and Elder J. T. Minchew, Primitive Baptist.

CHRISTIAN EDUCATION

CHRISTIAN; NON-SECTARIAN

In this age of materialism on the one hand, and occultism on in other, with streaks of infidelity here and there, while the Bible is virtually ruled out of the public schools; it is time for us to stress more than ever Christian Education. The Bible will be taught as a text-book in the school. The school, while Christian, will not be sectarian. It is our aim to make it deeply religious.

FACULTY

A SELECT FACULTY

It is gratifying to be able to present to the public a Faculty composed of men and women who hold degrees from leading Southern Colleges. These teachers are distinctly Christian.

Above is the history of the high school. (Courtesy of the Pierce County Historical & Genealogical Society, Inc.)

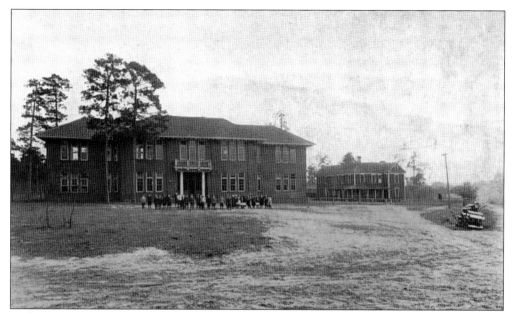

In this photograph stand the main building and girls dormitory of the Presbyterial Institute. To the far right is the road now known as College Avenue. (Courtesy of the Pierce County Historical & Genealogical Society, Inc.)

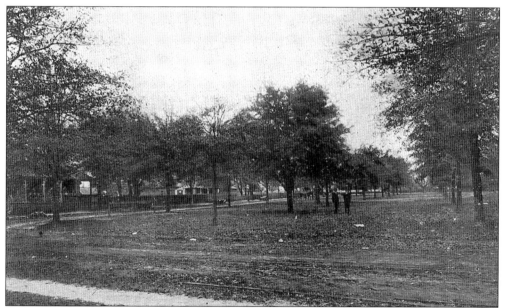

The Blackshear Park has always been a relaxing peaceful place where family, friends, and sweethearts could meet. These small oak trees have flourished through the years and now tower over the park to provide its visitors with shade and beauty. (Courtesy of the Pierce County Historical & Genealogical Society, Inc.)

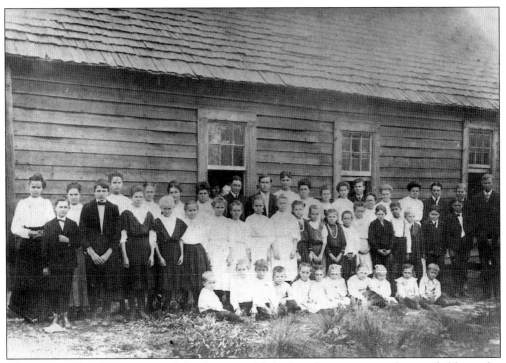

The Pierce Chapel Elementary School was established in the county to educate children who could not come into Blackshear for school. This class attended from 1908 to 1909. (Courtesy of Estelle Aycock.)

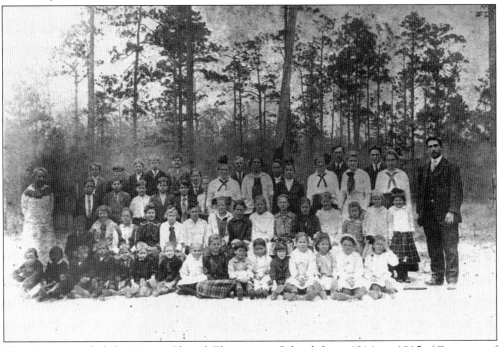

This class attended the Pierce Chapel Elementary School from 1914 to 1915. (Courtesy of Estelle Aycock.)

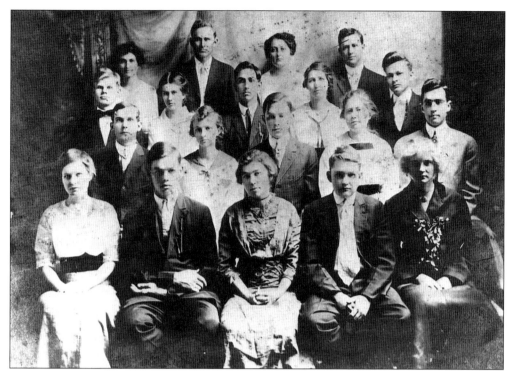

These were some of the teachers in Pierce County during the term of Superintendent R.D. Thomas. (Courtesy of Estelle Aycock.)

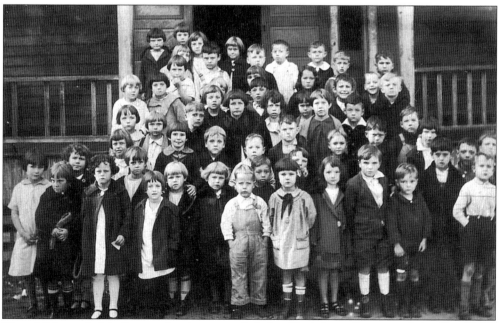

The children of this first grade class attended the Blackshear Grammar School in 1929. (Courtesy of Archie Davis.)

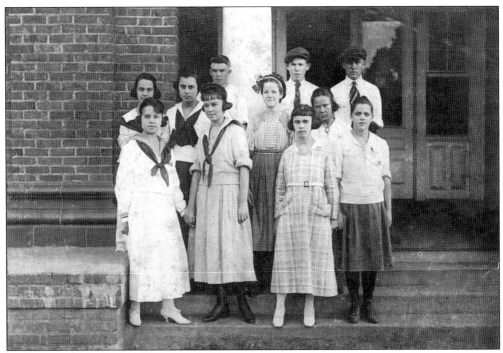

Standing on the steps of Blackshear High School, these ninth graders would later become the graduating class of 1920. (Courtesy of Archie Davis.)

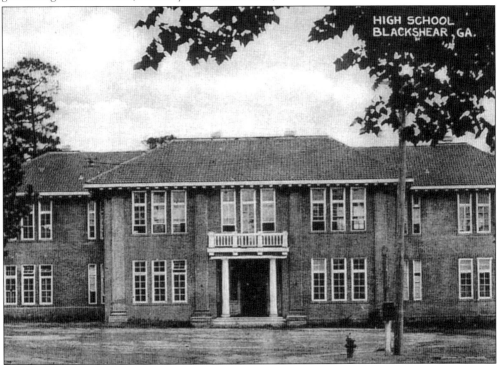

This is a postcard view of Blackshear High School, which was in existence from 1917 to 1980. (Courtesy of the Pierce County Historical & Genealogical Society.)

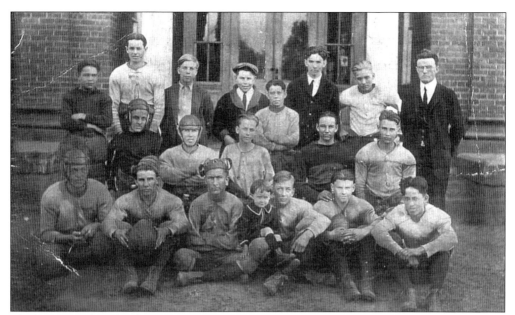

Blackshear High School established a football team that played area schools including Glynn Academy, Jesup High School, Douglas High School, and Douglas A&M. Because teams were small during that time, players had to be versatile enough to play several positions. (Courtesy of Huel Walker.)

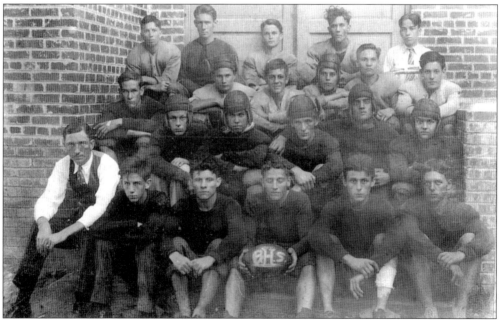

The 1928 Blackshear High School football included, from left to right, (front row) Coach W.D. Cathcart, Bill Davis, Buck Hurst, Truman Riggins, Joe Richardson, and Lyman Walker; (second row) Tom Jones, Marion Gray, John B. Culpepper, Preston Knowlton, and Clifford Knowlton; (third row) Jesse Memory, Buddy Bowen, George Richardson, Raymond Bulloch, Eli Hodge, and Bill Brown; (fourth row) D.L. Thornton, James Simpson, Marshall Thornton, Omer Lovett, and Ray James. (Courtesy of Huel Walker.)

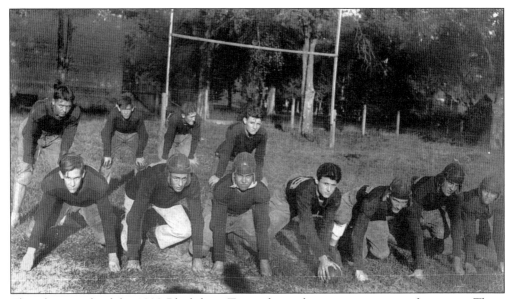

This photograph of the 1928 Blackshear Tigers shows them posing in game formation. These were the days when football was an exceptionally rough sport, with no facemasks and very little padding. (Courtesy of Huel Walker.)

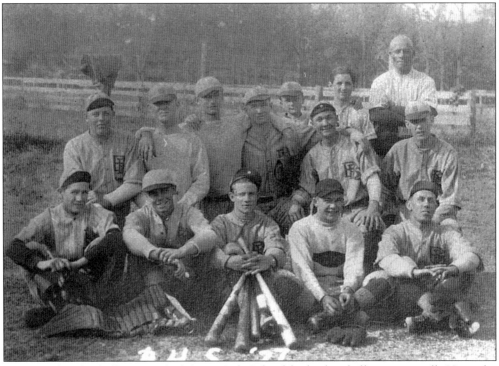

Along with a football team, Blackshear High School had a baseball team as well. Here, the team poses for a photograph. (Courtesy of Sallie Davis Strickland.)

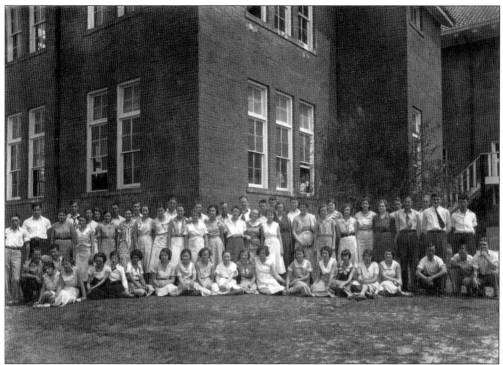

Many class photos were taken in front of Blackshear High School, as seen here. (Courtesy of Huel Walker.)

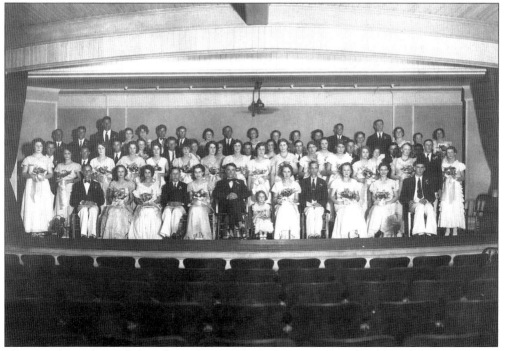

The proud members of the Class of 1932 of Blackshear High School stand for their senior photograph. (Courtesy of Huel Walker.)

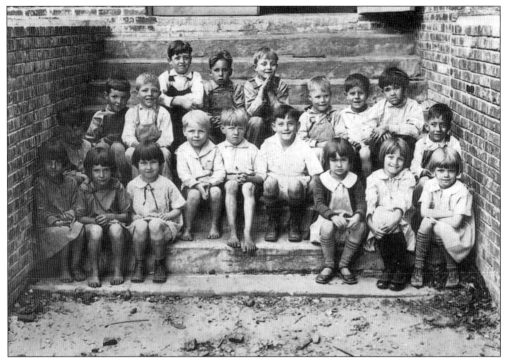

Wilbur Stuckey attended Blackshear Grammar School in the 1920s but moved away to complete grammar school in Hacklebarney. Wilbur is seated first on the left on the third step in overalls. He later graduated from Blackshear High School in 1938 and shortly thereafter joined the United States Marine Corps. (Courtesy of Wilbur Stuckey.)

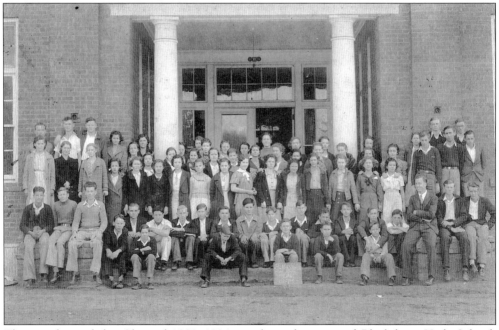

The members of the Class of 1933–1934 stand on the steps of Blackshear High School. (Courtesy of Archie Davis.)

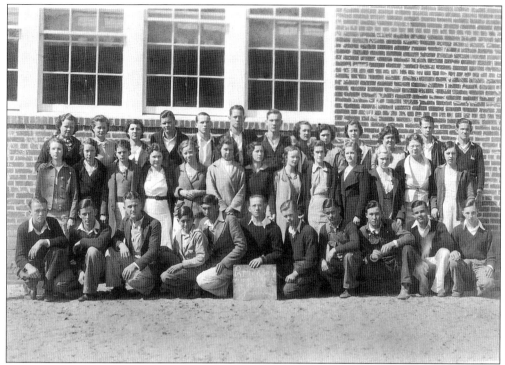

Other high schools were built in Pierce County as communities grew. The town of Patterson had its own high school, and pictured here is part of the graduating class of Patterson High School in 1935. (Courtesy of Leola Griner.)

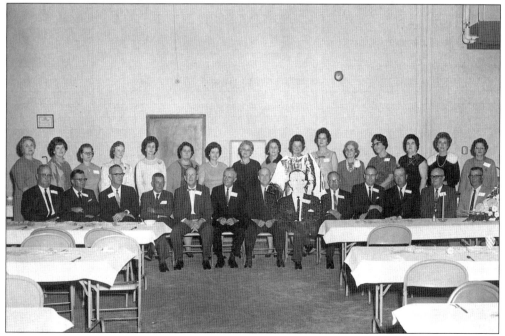

The Class of 1935 of Patterson High School gathered together in 1965 for a 30-year reunion. (Courtesy of Leola Griner.)

Many exciting basketball games, proms, dances, and other activities were held under the roof of the old Blackshear High School gymnasium. Constructed in the 1930s, it was funded by Work Projects Administration and President Franklin D. Roosevelt. The students would always shout out to their opponents, "Wait til' we get' em in the Barn!" This became the nickname of the gym. Unfortunately, the Barn mysteriously burned in the 1970s. (Courtesy of Ruth Hendry.)

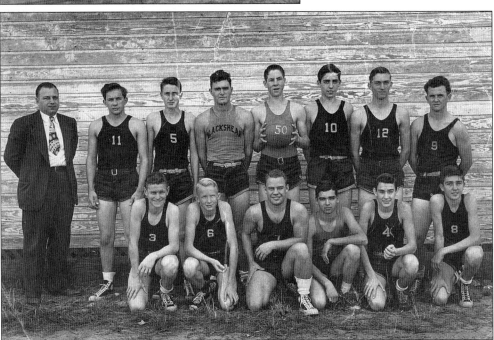

The 1950 Tigers basketball team of Blackshear High School pose in front of the Barn. Pictured, from left to right, are (standing) Coach Sobus, Buddy Davis, Owen "Tinkey" Harris, Deforest Walden, Ancil Strickland, Jimmy Davis, Harry Callahan, and Allen Dixon Jr.; (kneeling) William Wall, Lamar Boatright, Jerry Murray, Mack Crawford, Eugene Henderson, and Jimmy Strickland. (Courtesy of the Pierce County Historical & Genealogical Society, Inc.)

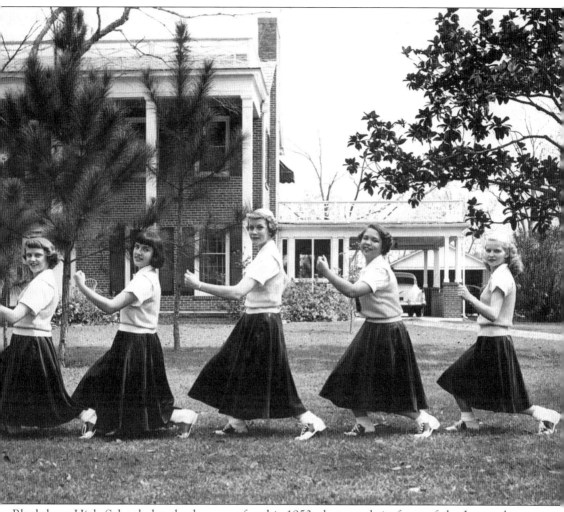

Blackshear High School cheerleaders pose for this 1953 photograph in front of the Leo and Janet Brantley Allen home on Main Street. Pictured, from left to right, are Carolyn Harris, Evelyn Schreiber, Shirley Dixon, Mary Lott Walker, and Clovis Thomas. (Courtesy of Mary Lott Walker.)

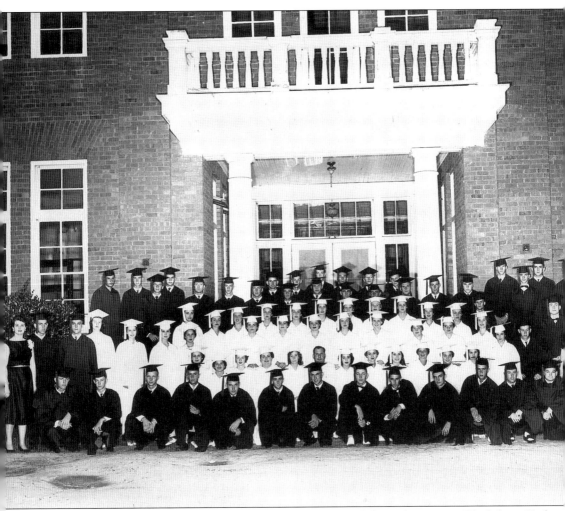

The proud members of the Class of 1957 pose in front of their alma mater, Blackshear High School. (Courtesy of Margaret Walker Guss.)

Seven

A LASTING LEGACY

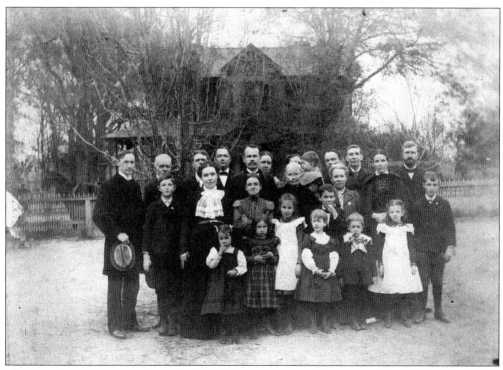

The Brantleys, a very prominent family in the county, were instrumental in helping Blackshear and Pierce County build a successful economy. The first brick tobacco warehouse to be constructed in the state of Georgia was built by the Brantleys. Members of the Benjamin Daniel Brantley and Janet McRae Brantley family stand in front of the old home of Confederate officer Capt. John C. Nicholls, which was located on Main Street. (Courtesy of Ruth Hendry.)

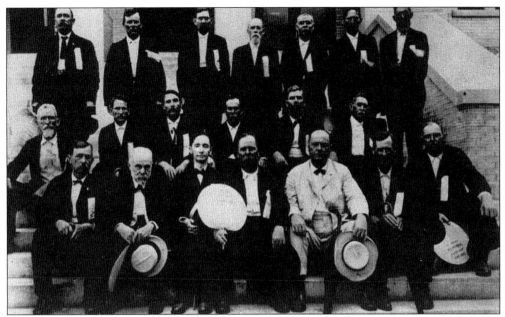

Farmers of Pierce County traveled on the Atlantic Coast Line train to North Georgia to learn more about new methods of farming. These farmers pose in front of the State Agricultural College in Athens, Georgia, where they had traveled to a farm conference on July 25, 1910. Pictured, from left to right, are (front row) A.L. Tuten, unidentified, John T. Brantley, Andrew Jackson Walker Jr., Tom A. Davis, Burley Davis, and Ben J. Guest; (middle row) Nathan Brown, James J. Aspinwall, Jacob Carter, S.L. Youmans, M. Wess Walker, and Ancil Byrd; (back row) John F. Dowling, A.C. Sweat, Jackson Walker, Randall Davis, Joseph Powers, J. Randall Bennett, and John G. Lee. (Courtesy of Ruth Hendry.)

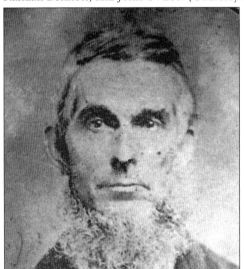 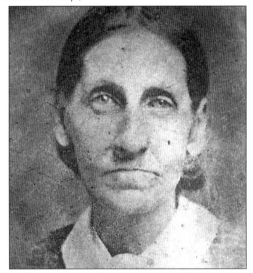

Joshua (June 6, 1821–March 2, 1896) and Eleanor Wilson Griner (December 9, 1824–October 5, 1893) were some of the first settlers in Pierce County. They moved to the area around 1853 and settled in the Otter Creek community. Joshua and his oldest son, Joe, fought for the Confederacy. Joe fought in the Western theater around Atlanta while his father fought in Virginia. When the war ended Joshua walked all the way home. (Courtesy of Helen Rowell.)

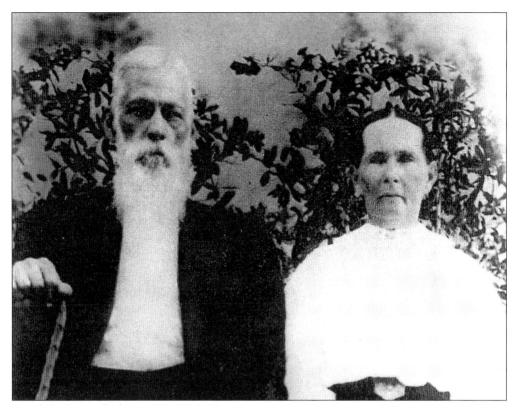

Joseph E. Griner (February 17, 1845–May 21, 1912) survived the war and married Charlotte Stevens (August 29, 1852–April 10, 1934). They had 12 children together. They are buried in the Strickland Cemetery near Patterson. (Courtesy of Leola Griner.)

Born on January 14, 1832, in Laurens County, Georgia, Benjamin Daniel Brantley was a self-made man and a prominent business owner in Pierce County. He served in the 4th Georgia Cavalry during the Civil War and would ultimately build a family dynasty. Due to his many achievements, the Georgia legislature later named Brantley County in honor of him. He and his sons are buried in the Blackshear Cemetery. (Courtesy of the Pierce County Historical & Genealogical Society, Inc.)

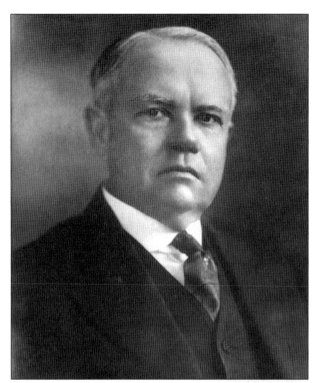

William Gordon Brantley Sr. was the eldest of the Brantley brothers and was born on September 18, 1860. One of his many accomplishments was serving in the United States House of Representatives for 16 years. After a successful political career, he was associated with the railroad. (Courtesy of the Pierce County Historical & Genealogical Society, Inc.)

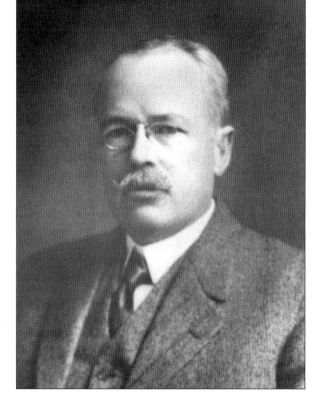

The second son of Benjamin Brantley, Archibald Philip Brantley was born on November 9, 1862. He followed in his father's footsteps, becoming a leader in agriculture and industrial development in Pierce County. (Courtesy of the Pierce County Historical & Genealogical Society, Inc.)

Benjamin Duncan Brantley, the third son of Benjamin, was born on December 4, 1864. He established the Brantley & Pomeroy Insurance Company. He was appointed to supervise the construction of the new courthouse, which stands today. In 1919, he assisted in the construction of the first tobacco warehouse in Blackshear, the Brantley Brick. (Courtesy of the Pierce County Historical & Genealogical Society, Inc.)

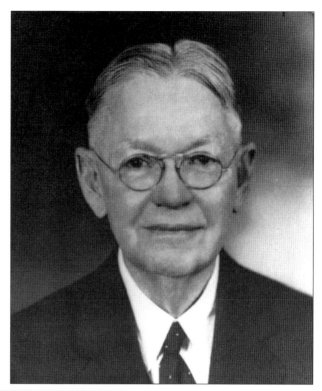

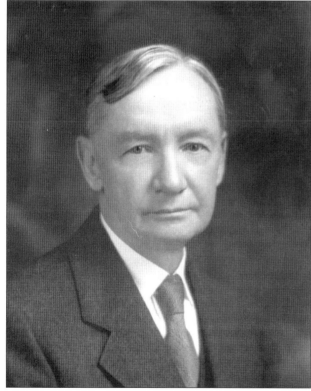

John Thomas Brantley, the fourth son of Benjamin, was born on December 17, 1867. He, too, would become a leader in business. Serving as vice-president of the Blackshear Manufacturing Company and the Blackshear Bank, John was very active in community endeavors such as the Presbyterial Institute. (Courtesy of the Pierce County Historical & Genealogical Society, Inc.)

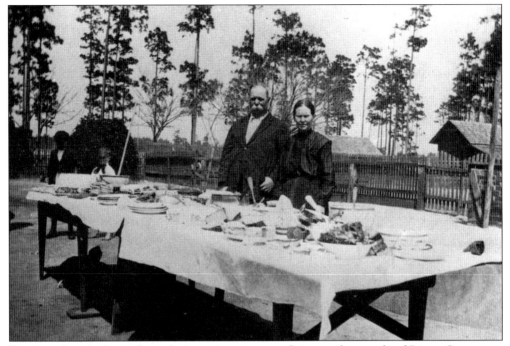

Family gatherings have always been an important tradition to the people of Pierce County—a time to get together for fellowship and some delicious home cooking. Andrew Jackson Walker Jr. (1861–1934)and Winifred Hyers Walker stand behind the table at one such gathering. Walker family reunions continue into the 21st century. (Courtesy of Alvin Walker Jr.)

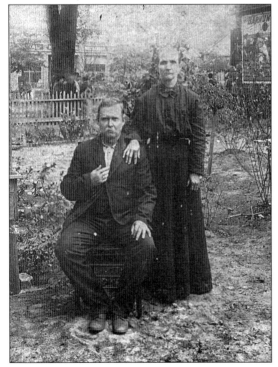

William Henry Peacock (1856–1921) and Rachel Ann James Peacock (1860–1936) pose in downtown Blackshear for a photograph. He was the son of Isham Samuel Peacock and Keziah Walker Peacock; she was the daughter of Ransom James and Rebecca Dowling James. In the background appears to be the Armitage Block of storefronts across from the city park. (Courtesy of Huel Walker.)

F. Fielding Kimbrell (1837–1904) and Piety Dixon Kimbrell (1842–1908) pose for this unusual style of photography. Piety was the daughter of Nathan Dickson and Elizabeth Byrd Dickson. (Courtesy of Huel Walker.)

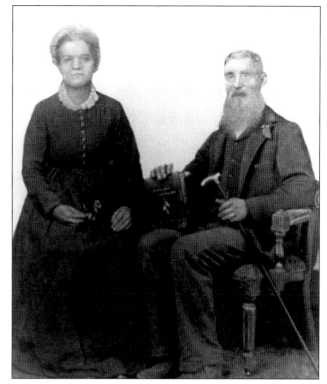

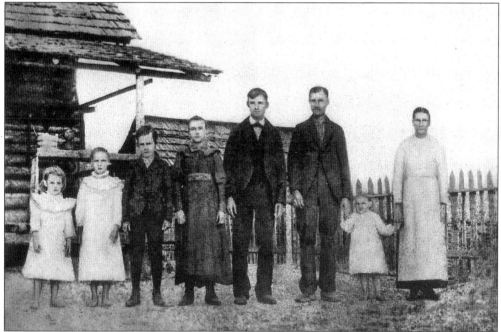

This photograph is believed to have been taken in the Hacklebarney community of Pierce County. Pictured, from left to right, are Julia Ann Sauls Tuten, Bessie, Abram David Tuten, Rachel, William Misner, James Holland, Addie, and Maggie Matilda, the mother of Wilbur Stuckey. She was born on August 22, 1884. (Courtesy of Wilbur Stuckey.)

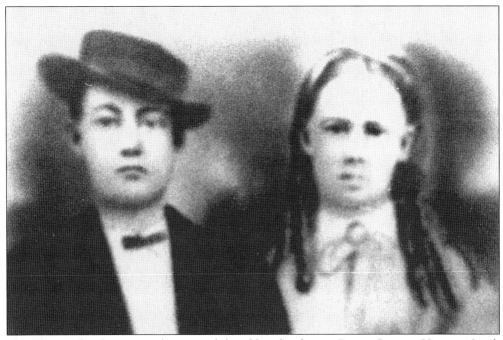

The Thomas family was another one of the oldest families in Pierce County. Here are Jacob Thomas (1851–1881) and Adeline Boyette Thomas (1855–1880) (Courtesy of Leola Griner.)

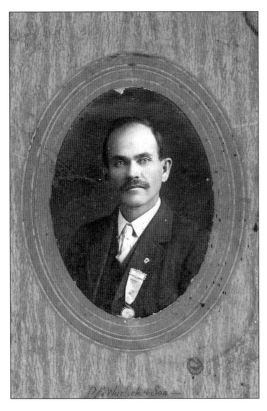

Elver Thomas (1870–1958) was the son of Rance J. Thomas and Mary Walker Thomas. He became one of the first mayors of Bristol. (Courtesy of Leola Griner.)

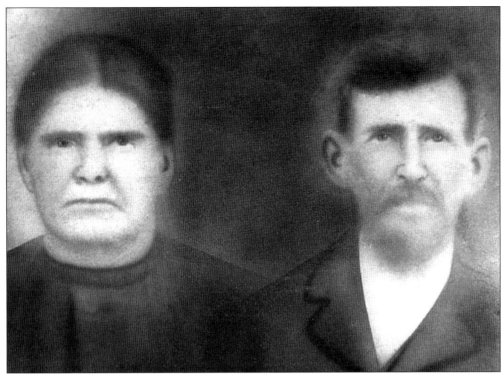

James Edward Batten and Charity Powers Batten are seen in this photograph. Charity was the daughter of Martha Ann Winn Powers Dixon and the granddaughter of Joseph Jones Winn. (Courtesy of Larry Batten.)

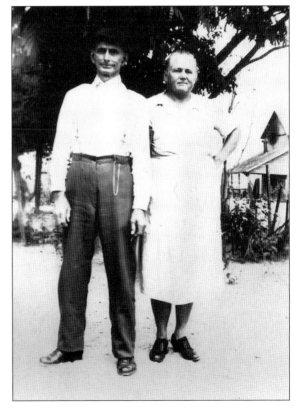

Mr. and Mrs. Batten were the grandparents of Carol, Edward, Nelda, Larry, Tony, and Marilyn Batten. (Courtesy of Larry Batten.)

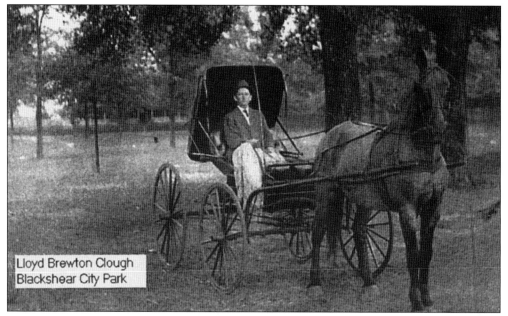

Lloyd Brewton Clough
Blackshear City Park

Lloyd Brewton Clough (1887–1952) is pictured taking an afternoon buggy ride in Blackshear City Park. (Courtesy of Rubye Clough Carter.)

In the 1850s there were only two known doctors in the region and none in Pierce County. However, as the town grew, doctors began to set up practice. Dr. and Mrs. William Parmelee Williams were very gracious in caring for the people of the area. Many members of the black community referred to him as "Dr. Jesus" because he took such excellent medical care of their needs. He was also an elder of Blackshear Presbyterian Church and taught Sunday school. (Courtesy of Mary Lott Walker.)

The McAlpin family is one of the oldest families in Pierce County. Here, Malcolm Canmore (July 2, 1867–December 21, 1923) and Elsie Mae Thompson McAlpin (d. July 6, 1940) pose for a portrait. He was the first cashier of the Blackshear Bank. (Courtesy of the McAlpin family.)

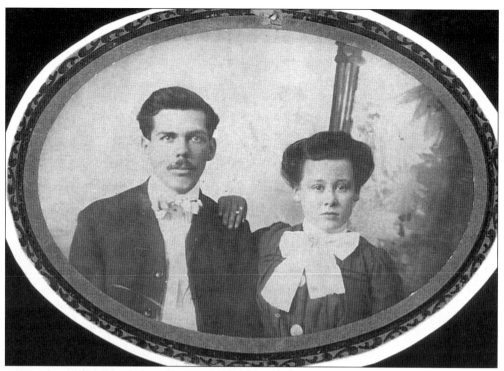

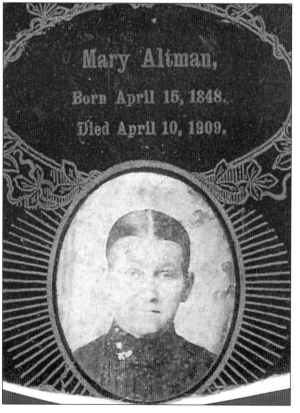

Above, James Walter Altman and his wife, Susie Rice Altman, pose after their marriage. They were members of Blackshear Presbyterian Church and had five children: Lucile, Edgar, Elberta, Ethel, and Mildred. Walter and Susie are buried in Blackshear Cemetery. (Courtesy of Elberta Altman Handley.)

Mary Johnson Altman was married to Edward Altman, and they were the parents of James Walter Altman. The couple is buried in the Shiloh Cemetery. (Courtesy of Elberta Altman Handley.)

Rachel, Tom, and Rebecca were the children of Ransom T. James and Rebecca Dowling James, both of whom are buried at Ben James Church Cemetery. Included in this photograph, from left to right, are Rachel Ann James Peacock (December 20, 1860–May 12, 1936), Tom James, Lem Johnson (August 4, 1862–August 13, 1938), Mrs. Tom James, and Mrs. Rebecca James Smith (March 10, 1865–December 5, 1938). (Courtesy of Ray James.)

A young Lee Purdom would grow up to become a successful attorney in Blackshear and Patterson and, later, state senator of Georgia. Lee Purdom was admitted to the Georgia State Bar in June 1932 and began a successful practice in Blackshear. He went on to become a state senator of the 46th district from 1937 to 1938 and 1949 to 1950. He took a leading role in the Pierce County Hospital and the Pierce County Housing Authority.

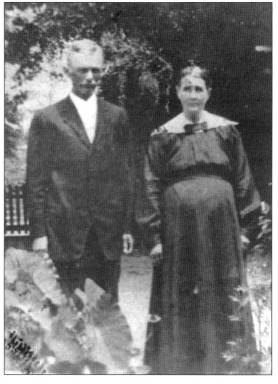

William Henry Bowen (January 24, 185–January 4, 1933) and Elizabeth Sikes Bowen (February 8, 1858–August 20, 1917) were pioneers who helped to build Pierce County. They constructed a beautiful two-story home around 1900 that is still occupied to this day. William was the county surveyor from 1895 to 1902. Both are buried in Waters Cemetery, south of Blackshear. (Courtesy of J. Charles Bryant.)

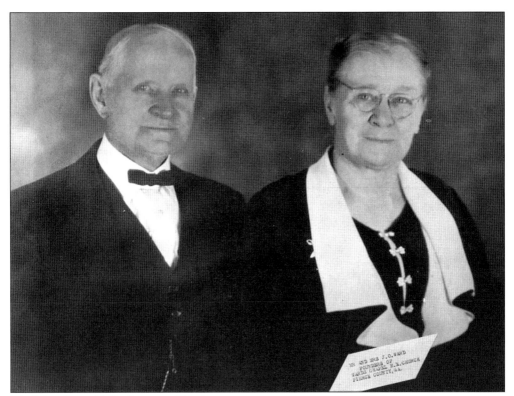

Mr. John O. and Lilla Brewton Ward were married on April 6, 1887. He moved to Pierce County from South Carolina and was a section foreman on the railroad. Together, John and Lilla founded Ward's Chapel Methodist Church as a Sunday school in 1899. He served as Sunday school superintendent for 32 years, and she taught Bible class until her death in 1945. (Courtesy of Ruth Hendry.)

These folks appear to be headed to church or another formal occasion. (Courtesy of the Pierce County Historical & Genealogical Society, Inc.)

This older gentleman is enjoying posing with this beautiful young woman in front of Blackshear High School. (Courtesy of the Pierce County Historical & Genealogical Society, Inc.)

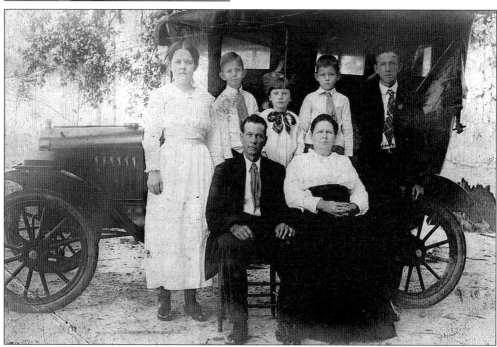

Mr. William O. and Mrs. Mary Jane Boyette Griner pose in front of their automobile with their children. Standing behind them, from left to right, are Lillie, Joe, John, Josh, and Owen. (Courtesy of Leola Griner.)

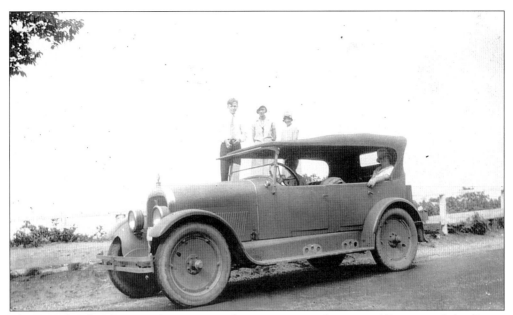

The Brantley family poses for a picture during a trip to the coast. (Courtesy of the Pierce County Historical & Genealogical Society, Inc.)

Ruby Lee Wilson grew up in Offerman. She later married Olin Wilson in Patterson. (Courtesy of granddaughter Christy Wilson.)

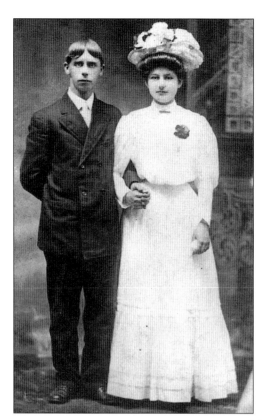

James Walker (1885–1963) was a farmer in the Otter Creek community and served on the board for the Otter Creek School. He is pictured here with his wife, Kizzie Johns Walker (1886–1963). (Courtesy of Huel Walker.)

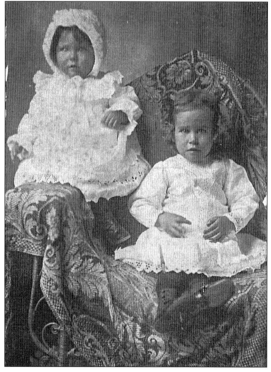

These two adorable children are Lyman Lyman Jackson Walker (left) and Moselle Walker (right). Lyman grew up in Pierce County and remained there all his life. He taught school as a young man and later became heavily involved with brother Alvin Walker Sr. in agriculture. Moselle taught school in Blackshear, Savannah, and Augusta. She married Enoch H. Hurst Jr. and raised a family. She is buried in Greenville, South Carolina. (Courtesy of Huel Walker.)

Benjamin Martin Peacock (1889–1953) and Georgia Kirby (1894–1999) were married in Pierce County. Benjamin ran a shoe store in downtown Blackshear. Georgia lived to be one week shy of 105 years old. (Courtesy of Huel Walker.)

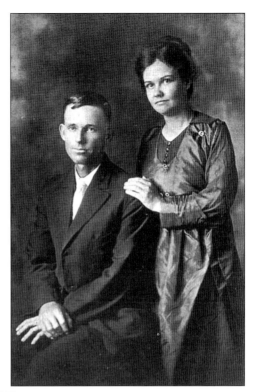

Huel Pauline Peacock, the daughter of Ben and Georgia Peacock, married her high school sweetheart Lyman Walker. They were married for more than 50 years until his death. They were both outstanding citizens in the community, teaching throughout their careers. Huel Peacock was president of the Class of 1929 at Blackshear High School. (Courtesy of Huel Peacock.)

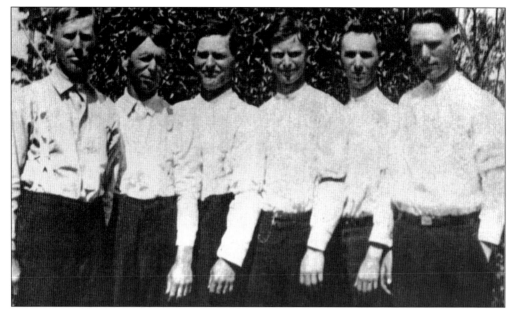

The sons of Andrew and Winifred Hyers Walker Jr., from left to right, are Isaiah (1881–1962), James (1885–1963), Lanier (1888–1948), David (1893–1951), Jacob Walker (1895–1927), and Edwin (1900–1960). James was the father of Lyman, Oliver, and Alvin. (Courtesy of Alvin Walker Jr.)

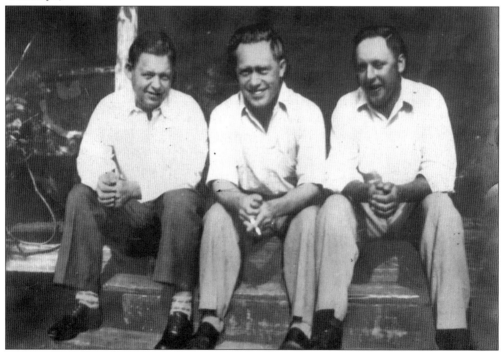

The Walker brothers, who grew up in Pierce County, are, from left to right, Lyman, Oliver, and Alvin. Lyman and Alvin remained in Pierce County all their lives and helped to build the agricultural economy. Oliver later moved to Salisbury, North Carolina. (Courtesy of Huel Walker.)

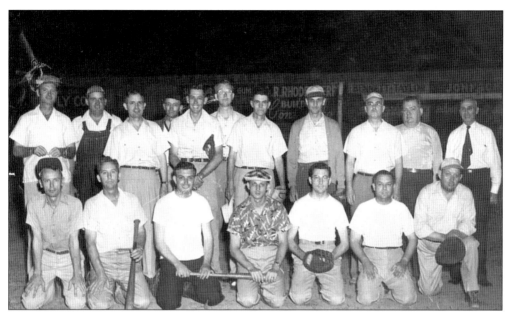

Many clubs, churches, and businesses formed their own softball teams. Friday and Saturday nights were exciting and the community would come out to watch a little friendly competition. Included in this picture are Jim Hendry, Riley Allen, Irvin Gilmore, Alvin Ratliff, Lyman Walker, Ancil Davis, Dr. Bill Hendry, Julian Dean, Mack Carter, Ob Williams, Dr. Bill Brown, Dean Broome, Harvey Griffin, Forster Memory Jr., George Schlegel, Lee Purdom, and Rev. Linton Johnson. (Courtesy of Huel Walker.)

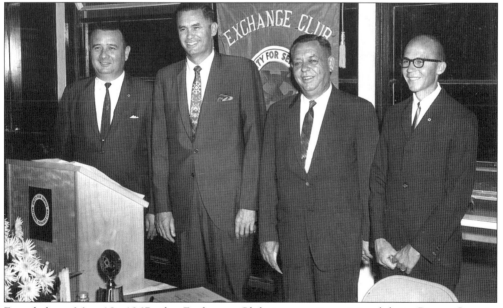

Founded on May 18, 1967, the Exchange Club is an active civic club in Pierce County. This photograph was taken inside the Blackshear High School dining room at the charter meeting. Charter officers are, from left to right, Judge Francis Houston, president; Robert A. Johnson, vice president; Lyman Walker, secretary; and Joseph M. Clark, treasurer. (Courtesy of Huel Walker.)

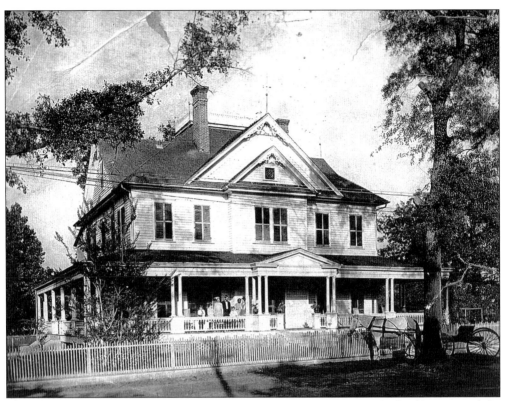

This home stands on the site of the former home of Capt. John C. Nicholls. (Courtesy of the Robert Morris family.)

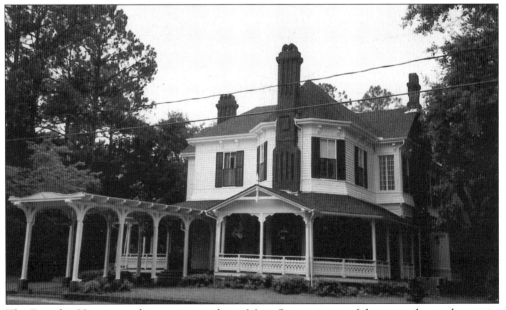

The Brantley Home, standing prominently on Main Street, is one of the most elegant houses in all of Pierce County. This was the home of A.P. Brantley and Ella Foreacre Brantley. (Courtesy of John Guss.)

Eight

MEMORABLE EVENTS

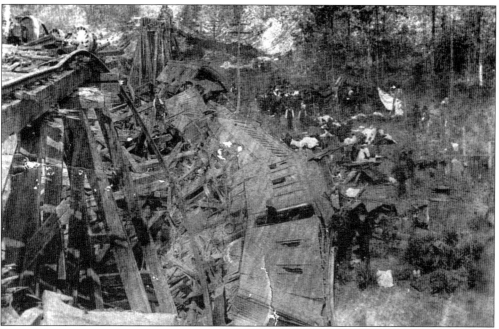

One of the most significant catastrophes in Blackshear's history was the train wreck on March 17, 1888, at the Hurricane Trestle just outside the east entrance to Blackshear. As the train passed across the 37-foot-high trestle over the Alabaha River, the bridge began to give way, as the engineer later reported. The wooden trestle collapsed, sending passenger cars crashing into the bed of the Alabaha River. Local citizens and physicians raced to the scene to aid the victims. At least 22 people died and more than 30 were injured. The bodies were brought to the railroad depot and laid out for identification. The wreck was later believed to have been caused by a brake mechanism, which fell from its place ripping across ties from the track. When it hit the wooden trestle, it literally tore the bridge from under the train. (Courtesy of the Pierce County Historical & Genealogical Society, Inc.)

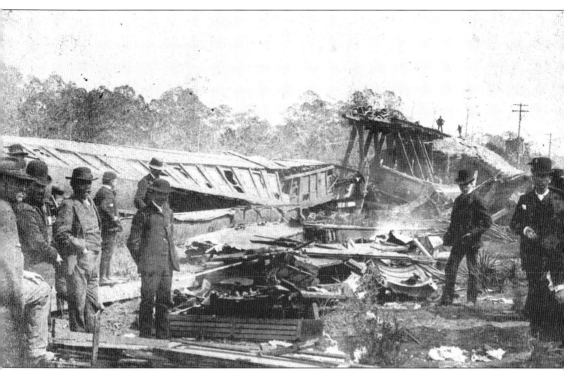

John B. O'Neal and John T. Brantley were two of the first to arrive on the scene of this horrific accident. Other citizens raced from downtown Blackshear to aid the dying and wounded. Buckets of water were hauled up toward the wreckage to put out fires, which were consuming the crushed cars. One citizen of Blackshear, John T. Ray, is known to have died in the wreck. (Courtesy of Ruth Hendry.)

Many of Pierce County's sons went off to serve in World War I, and eleven men would not return home. In their memory, a plaque was placed on the Memorial Bridge between Pierce and Ware Counties. These unidentified soldiers pose for the camera while enjoying a drink to take their minds off the severities of war. (Courtesy of the Pierce County Historical & Genealogical Society, Inc.)

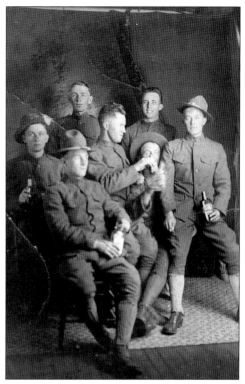

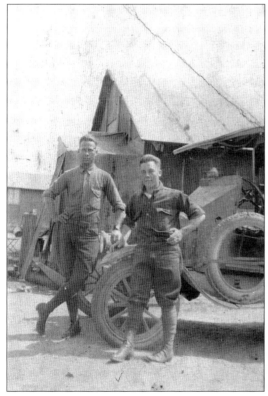

Approximately 300 Pierce County men, 232 white and 76 black, served in the U.S. military during World War I. Frank Kirby was one of those brave soldiers. Here, Frank (left) and an unidentified comrade pose for a photograph in camp. (Courtesy of Huel Walker.)

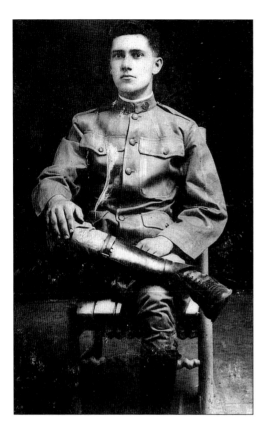

Melvin Anderson was born in 1900 and lived in a community within Pierce County called Bristol. Melvin joined the army and fought in World War I. He is buried in Norfolk, Virginia. (Courtesy of Leola Griner.)

O.L. Roberson served in World War I, and here he poses for a photograph in France in 1918. He returned home to Pierce County to take over the duties of sheriff after his father's death. (Courtesy of John Roberson.)

PREMIUM LIST

◉◉◉

PIERCE COUNTY FAIR

October 16th, And 17th, 1917,

BLACKSHEAR, GEORGIA.

Citizens gathered throughout the county on October 16, 1917 for the one-day Pierce County Fair. One citizen described it as the biggest day Pierce County ever had. Much of the success of the fair was due to Pierce County Farm Demonstrator T.B. Wiley and his wife. (Courtesy of the Pierce County Historical & Genealogical Society, Inc.)

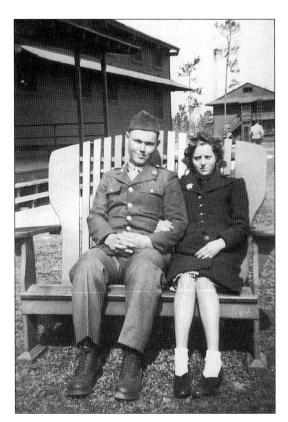

Melvin Denison joined the U.S. Army along with 1,192 other Pierce County men and headed off to World War II. He was one of the fortunate ones who returned home. He married his sweetheart Carrie; they built a home together and raised a family in Offerman. (Courtesy of Brenda Denison.)

TEN PERSONAL ILLUSTRATIONS

GOD ANSWERS PRAYER

BY AN EX P.O.W.

THEN — REV. CLYDE THOMAS NOW

A MAN FROM BATAAN

Clyde Thomas endured the greatest challenge any soldier can face in war—being held captive as a prisoner of war. During World War II, he was captured in the Pacific theater and became a part of the infamous Bataan Death March in which American soldiers were brutally killed by their Japanese captors along a grueling 65-mile march. Those who could not keep up were bayoneted or shot and left along the trail. His fortitude and strong faith in God brought him home alive. Thomas later became a devoted minister, preaching here in Pierce County and in other areas. (Courtesy of the Pierce County Historical & Genealogical Society, Inc.)

On Wednesday, October 16, 1957, everyone came out for the Brantley Company celebration saluting 100 years of prosperity. The company helped establish Pierce County as a sound economic community. Decorative floats and several bands from the area marched through the streets during the birthday celebration. This parade photo looks back at the courthouse. (Courtesy of the Pierce County Historical & Genealogical Society, Inc.)

The Brantley Company affected the lives of almost everyone in Pierce County. Not only was the celebration in recognition of the Brantley achievements, but it was also an occasion for all to feel a part of the accomplishments. (Courtesy of the Pierce County Historical & Genealogical Society, Inc.)

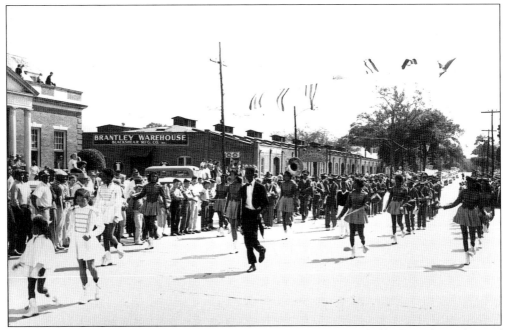

The celebration included everyone throughout the county, young and old. Here, the students of the Lee Street High School band march down Main Street before a cheering crowd of hundreds. (Courtesy of the Pierce County Historical & Genealogical Society, Inc.)

In 1969 and 1970, Blackshear High School led all of the schools from across the state of Georgia as the President School for the Georgia Association of Student Councils. Pictured, from left to right, are Fred Marceaux, Susan Pritchard, Fred Hobbs Jr., Jane Bowen, Sonny Bowen, teacher Mary Lott Walker, and Principal Doris Raulerson. Walker was a government teacher at Blackshear High School and the Student Council advisor; she went on to serve as the overall state advisor for over 25 years. (Courtesy of Mary Lott Walker.)

INDEX